D1383401

THE COMPLETE
MARVEL
COSMOS

WITH NOTES BY THE GUARDIANS OF THE GALAXY

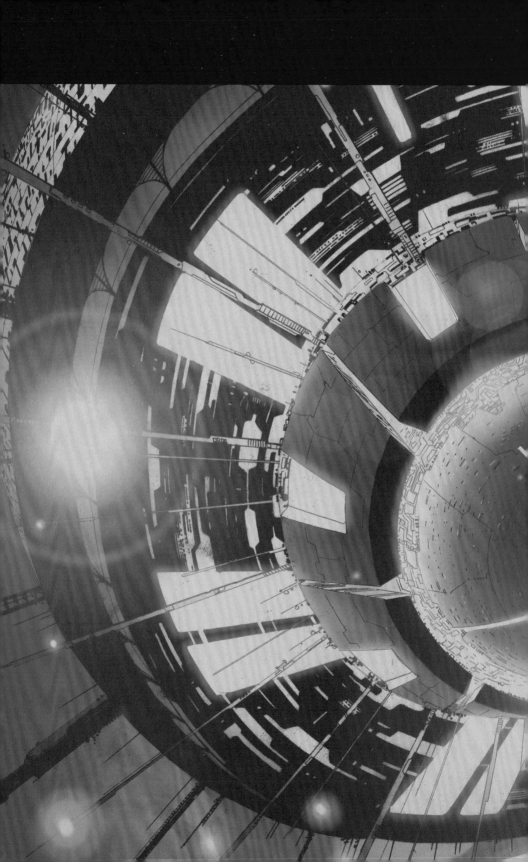

MARVEL

THE COMPLETE

MARVEL
COSMOS

WITH NOTES BY THE GUARDIANS OF THE GALAXY

BY MARC SUMERAK

INSIGHT EDITIONS

San Rafael, California

CONTENTS

Alternate Universes

INTRODUCTION

TO ETERNITY . . . AND BEYOND!

Greetings, galactic voyagers!

Welcome to an in-depth guide to the universe's greatest hot spots. For the first time, in one volume you'll find everything you need to know to plan successful visits to dozens of the most buzzed-about alien worlds and alternate dimensions in all of reality.

Want to know where to get the best drinks on the edge of existence? Or which species is most likely to throw you into their fighting pits? Then this is the guide for you!

There's a perfect vacation out there for every type of traveler. Some may prefer a whirlwind tour through the vast Shi'ar Empire, while others simply crave a serene getaway to the forests of Planet X. And readers looking for extreme thrills will find dozens of dangerous locales to test their survival skills, from Monster Isle to the Cancerverse!

Offering quick, easy overviews of each location that focus on everything from culture and customs to restaurants and attractions, this guide is the perfect way to decide which destinations deserve a closer look and which should be avoided at all cost.

There's a whole universe out there ready to be explored. Once you've finished reading, you'll have everything you need to hit the stars with confidence!

HEY THERE! IT'S YOUR PAL, PETER QUILL-AKA THE LEGENDARY STAR-LORD! AS YOU'RE READING, YOU MAY NOTICE THAT THIS BOOK IS SCRIBBLED FULL OF HELPFUL HINTS AND RANDOM FACTS COURTESY OF MY TEAM, THE GUARDIANS OF THE GALAXY.
-STAR-LORD

You may ask yourself, why would we share our vast wealth of interplanetary knowledge with a bunch of random wannabe spacemen? Because we care—about not having to clean up after you when you make a complete flarkin' mess of our favorite universe.
—Rocket

What Rocket is trying to say is that we have discovered a great deal on our many journeys, and the wisdom we have gained might help to shed some light on the best—and worst—these unique locations have to offer. —Gamora

Okay, maybe Gamora's right for once. We've done a lot of crazy things over the years, and you might as well have the chance to learn from our . . .

I AM GROOT.

I was gonna say "adventures," but yeah, "mistakes" is probably more accurate.

BAH! WHERE IS THE SENSE IN THIS? WHY WASTE OUR TIME WRITING WHEN WE COULD INSTEAD BE OUT FIGHTING?—DRAX

Because, sometimes, Drax, the pen is mightier than the sword.

THAT IS A BLATANT LIE! I JUST CLEAVED A WRITING TOOL IN HALF WITH EASE AND LAUGHED AS IT BLED ITS FINAL DROPS OF INK.

DON'T MIND DRAX, FOLKS. HE'S A BIT INTENSE. BUT HIS HEART IS IN THE RIGHT PLACE.

MY CHEST.

ANYHOW, I HOPE THIS BOOK MAKES IT INTO THE HANDS OF SOMEONE WHO IS JUST AS EAGER AS I ONCE WAS TO LEARN ABOUT THE WONDERS BEYOND THEIR HOME PLANET.

And if you ever find yourself stranded on one of these crazy worlds, even if you don't remember anything else you learned in these pages, just be sure to ask yourself this one question and you'll be fine:

I AM GROOT?

That's the one! Happy traveling!

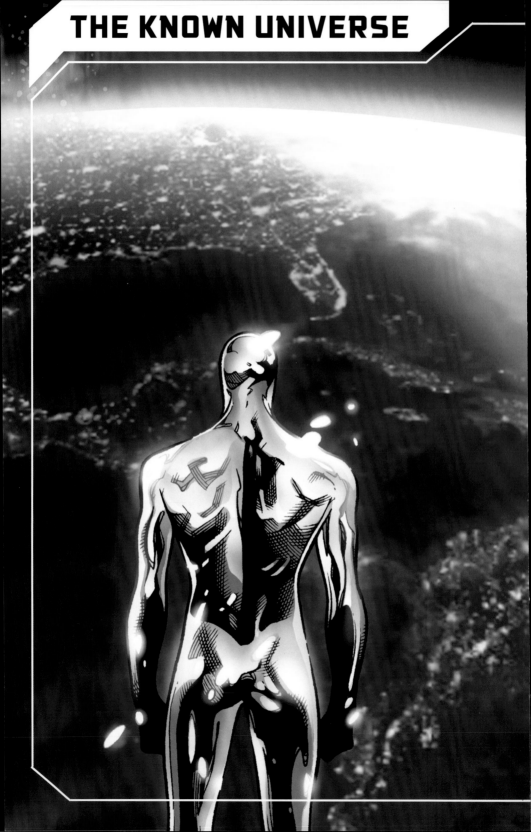

YOU ARE HERE

We all want to believe that we are special. That intelligent life is a distinct and singular experience shared only by members of our own species. But there comes a time in every civilization when the evidence of life beyond our home planets becomes too abundant to ignore. That is when we begin to explore. *Or when we get eaten by Galactus. One of the two. —Rocket*

Of the hundreds of billions of planets in the known universe, only a small percentage of them are inhabitable. But a small percentage of "hundreds of billions" is still "billions." Each of those planets offers something unique to the universal tapestry and is worth a closer look.

WE'RE GONNA NEED A BIGGER BOOK . . . -STAR-LORD

There are a few planets, however, that stand out from their celestial brethren. Some of these worlds are the birthplaces of legendary cosmic empires. Some of them are nurturing promising young civilizations on the brink of joining the larger galactic community. Some of them are eagerly searching out the next target in their brutal quest for universal domination. And some of them simply serve the best plate of shi'xri you'll ever taste. *Let's go to that last one. Thinking about Galactus made me hungry.*

These are the planets we will be focusing on in this volume. The ones that have made a significant impact—either good or bad—on their universal neighbors. Once you have a better understanding of these wildly different worlds and the cultures that call them home, you'll be prepared for almost anything the universe can throw at you.

EXCEPT A Z'NOX QUANTUM GRENADE. NO ONE IS EVER PREPARED FOR THAT.-DRAX

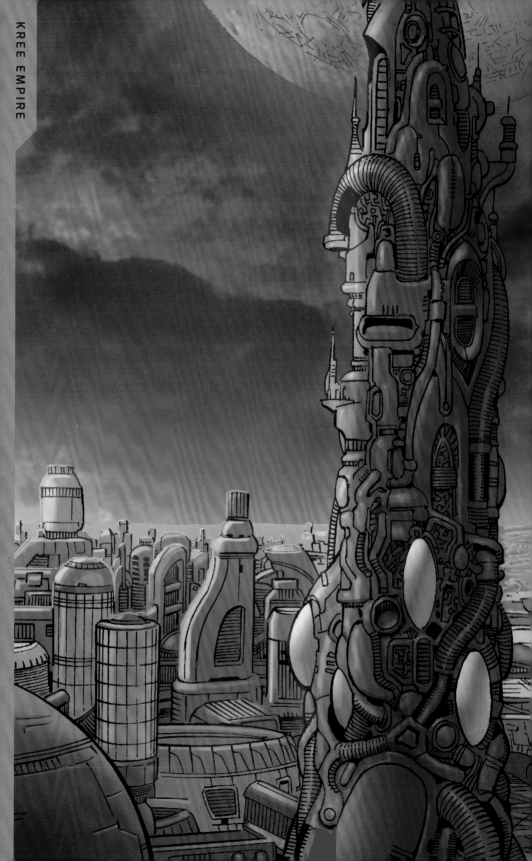

KREE EMPIRE

THE PRIDE OF PAMA

Spanning thousands of worlds, the Kree Empire is recognized as one of the most powerful military forces in the known universe. Their presence has been felt far beyond the reaches of their empire and has steered the development of countless cultures across the galaxy.

AND HAS TICKED OFF JUST AS MANY. —STAR-LORD

HISTORY AND CULTURE

Originating on the planet Hala in the Pama System of the Greater Magellanic Cloud, the Kree were one of two dominant races on their home world. The other—a peaceful plantlike race called the Cotati—were almost completely exterminated by the warlike Kree a million years ago during a conflict incited by a visiting race of shape-shifting aliens known as the Skrulls.

I AM GROOT! *You're right. There's no excuse for herbicide. —Rocket*

This same dispute led to the primitive Kree obtaining a Skrull starship, the first step toward the Kree culture becoming a spacefaring civilization. The theft of the ship and the slaughter of countless Skrulls and Cotati, however, earned the Kree a ruthless reputation across the galaxy and began the epic Kree-Skrull War that would continue for nearly a million years.

Renowned as a warrior culture with unmatched battle prowess, the Kree built an armada of ships and assembled one of the largest and most effective military operations ever seen. Their development was guided by the Supreme Intelligence, an artificial construct housing the assembled knowledge of the Kree Empire's greatest scientific and military minds. *Including a great recipe for Kly'rishi kabobs.*

The Kree upper class is primarily composed of the blue-skinned members of the race, who are considered to be "purebred." Although greater in number, the pink-skinned Kree are looked down upon by their blue cousins because they are the product of unions between the Kree and other conquered civilizations. Despite this difference in skin color, most of the Kree's other physical attributes are identical. *And they all feel the same against my fists. —Gamora*

Recently, the planet Hala, the birthplace and capital of the Kree empire, was destroyed during a conflict. A large percentage of the Kree Empire's military and leadership—including the Supreme Intelligence itself—is believed to have died with the planet.

IT WASN'T OUR FAULT! I SWEAR! –STAR-LORD

BUT IT WAS QUITE A SIGHT TO BEHOLD. –DRAX

Although the Kree Empire has recovered from near obliteration in the past—most notably after the detonation of the Shi'ar Nega-Bomb—it remains to be seen what form this star-spanning society will take once it rebuilds.

ETIQUETTE

The Kree keep close eyes on visitors from other races and are not tolerant of any actions that stray beyond the strictly regimented rules of their military-based culture. Even the slightest affront to Kree law will land you in front of one of the Accusers. These hammer-wielding lawmen act as judge and jury—and, far too often, executioner.

PLEASE, HAMMER, DON'T HURT ME!

WHAT TO WEAR

Because of their military culture, Kree citizens tend to be rather formal in their attire. Casual vacation wear that reveals a great deal of flesh will be frowned upon, even in the hottest of the Empire's climates. A reinforced flight suit should cover all of your needs, though lightweight body armor is recommended for members of any species who are engaged in ongoing conflicts with the Kree. You know who you are.

The air on most Kree-ruled planets is richer in nitrogen than many of the other breathable atmospheres in the galaxy. While a full life-support system is likely overkill, you may want to bring a supplementary oxygen supply if you anticipate any strenuous activity.

IS "FIGHTING TO THE DEATH" CONSIDERED STRENUOUS?

SIGHTS AND ACTIVITIES

Not for me. –Gamora

Despite their reputation as warriors, the Kree take a great deal of pride in their empire and its rich history. In recent years, the Kree have spent almost as much on cultural preservation initiatives as they have on military advancements. This shift has led to a significant increase in tourist travel because of those interested in learning more about the Kree's pivotal role in the development of the civilized universe.

Although the Kree's most prominent tourist destination, Hala, is no more, there are still thousands of planets in their empire worth a trip. Be sure to visit Cyllandra, the planet housing the Kree Empire's historical library. With the Supreme Intelligence gone, this repository is your best remaining resource to research the Kree's vast history. Valid identification is required to borrow books.

They have books there? I just visit for the free Internet. —Rocket

 ## TIPS FOR A FUN TRIP

DO: Stand strong. The Kree may be imposing, but they respect those willing to fight for what they believe in. A Kree can go from enemy to ally in a matter of minutes.

And back to enemy in seconds.

DON'T: Fall in love. A small fraction of the Kree's female populace is born with the ability to psychically manipulate the desires of men. Be careful not to lose your heart—or your credits! ***THAT EXPLAINS SOME THINGS.***

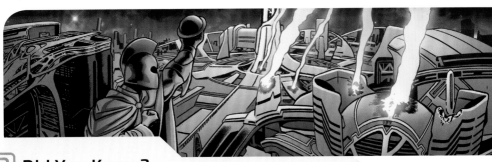

? Did You Know?

• Not all of the Kree are warriors. In fact, a peaceful sect of Kree known as the Priests of Pama was founded millennia ago to help smuggle the remaining Cotati safely off the planet. These priests continue to spread teachings of peace throughout the galaxy. *Buncha tree-huggin' hippies!* **I AM GROOT!** *Not that there's anything wrong with that . . .*

• Kree bodies are much stronger and more durable than similar species on other planets (such as the humans of Earth) and have evolved to incorporate duplicates of many vital organs.

The more places to stab, the better!

• The Kree once used the Forever Crystal to jump-start their own evolution. The result was a race called the Ruul—beings able to adapt their physiology to survive any environment. This evolutionary shift has since been reversed, returning the Kree to their original forms and erasing almost all traces of the Ruul from the empire. ***SO, I GUESS THE RUUL HAS BECOME THE EXCEPTION?***

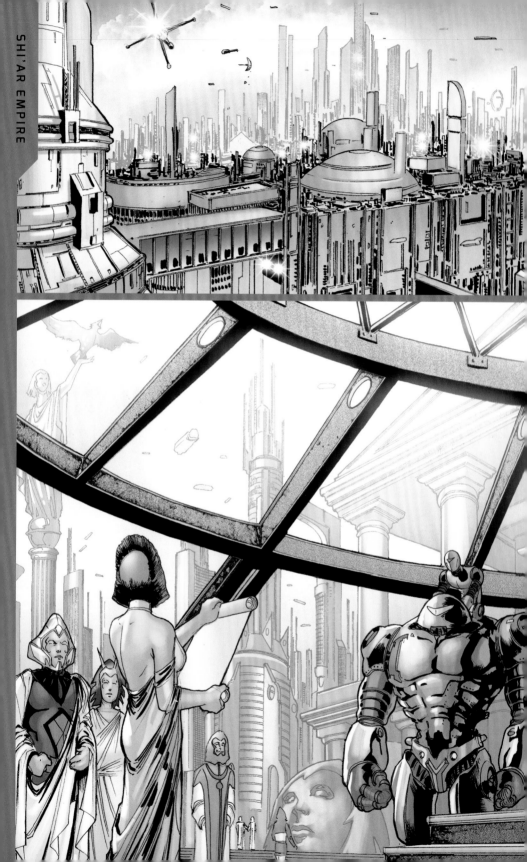

SHI'AR EMPIRE

HEY! THAT'S OUR GIG!
—STAR-LORD

SUPERGUARDIANS OF THE GALAXY

Known for its advanced technology and swift imperial justice, the Shi'ar Empire has become one of the most prominent civilizations in the universe. Ruling every one of the millions of planets in their home galaxy, the Shi'ar are always eager to expand and advance their culture.

 ## HISTORY AND CULTURE

The Shi'ar race originated on the planet Aerie in the Andromeda Galaxy (known on Earth as M-31). Due to unmatched technological developments and unyielding ambition, the Shi'ar were able to increase their empire's influence much faster than similar conquering races like the Kree and Skrull.

The Shi'ar are known for aggressively annexing worlds into their empire to augment its power. Their colonization philosophy is rooted in an ancient story of their gods, Sharra and K'ythri, who were forced to marry against their wishes but later came to love each other, their pairing bringing them great combined strength. The lack of turmoil between planets in the Shi'ar galaxy suggests that their philosophy may be sound. *Religion justifies madness far too often. —Gamora*

But at least it gets me out of monitor duty on Sundays. —Rocket

One interesting characteristic that sets the Shi'ar Empire apart is the diversity of its populace. Other empires, such as the Kree and Skrull, set out to take planets from their indigenous cultures and repopulate them with their own species. When the Shi'ar annex a planet, even by force, the native species is allowed to remain intact and continue development under the empire's watchful eye.

Shi'ar leadership rules from the planet Chandilar, an artificially constructed throneworld at the heart of their galaxy. Chandilar is also the home base of the Imperial Guard, a group of highly trained warriors handpicked from the empire's member-planets to serve as the protectors of the Shi'ar Galaxy and beyond. Thousands of Subguardians fight to keep the empire safe, while the most elite members from each power class—the Superguardians—directly serve the Majestor himself.

WE TOTALLY NEED TO RECRUIT SOME SUBGUARDIANS TO DO OUR DIRTY WORK!

I thought that's why we had Rocket and Groot.

As one of the most prominent civilizations in the galaxy, the Shi'ar have often found themselves entrenched in matters of immense cosmic importance. Their willingness to confront even the greatest cosmic threats has earned the Shi'ar a reputation as intergalactic protectors.

And our willingness to clean up their messes has earned us squat!
—Rocket

GETTING AROUND

Traversing the Shi'ar Empire is a breeze, thanks to stargates developed by their scientists. These portals allow you to make instantaneous leaps from one end of the Shi'ar Galaxy to the other—and every hot spot in between!

SIGHTS AND ACTIVITIES

Tribunal Hall: For those interested in witnessing the swift hand of universal justice in action, the Shi'ar Tribunal Hall is a must-see. This massive arena is where delegates from each Shi'ar planet are summoned together for trials. Those who have committed a crime against the empire are likely to end up on this stage—for one final performance. *OR, IN OUR CASE, FOR COUNTLESS ENCORES. -STAR-LORD*

M'Kraan Crystal: This giant pink diamond is said to be as deadly as it is beautiful. Actually a "nexus of all realities," the crystal contains a neutron star that links together alternate universes. If damaged, the crystal could create a black hole that consumes all of existence. Souvenir replicas are available at the gift shop in the lobby.

Oooh! Shiny! Can we steal it? Can we? Can we? PLEASE?

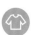 # WHAT TO WEAR

While visiting the Shi'ar Empire, dress respectably and inconspicuously. Since the empire comprises a multitude of species, it can be easy to blend into the crowd. Those who draw attention to themselves are more likely to run into trouble. Basic colors and simple fabrics are recommended.

SHOPPING AND ENTERTAINMENT

LODGING

Don't expect much in the way of entertainment during your visit. The Shi'ar generally view artistic creativity as an infection and even a sign of insanity. This stems from the Shi'ar race's inability to dream and use imagination. In fact, those Shi'ar who can dream are seen as inferior and have often been executed for their flaws!

MY DREAMS ARE HAUNTED BY THE FOES I HAVE VANQUISHED. I WOULD TRULY MISS THEM. —DRAX

While on Chandilar, be sure to pay a premium to upgrade your room to a holo-suite. The Shi'ar have perfected a form of hard-light hologram projection capable of simulating any environment. Although these state-of-the-art rooms were originally designed to help visiting dignitaries from alien worlds feel more at home during their stay, they are now available to the general public. With the press of a few buttons, you can spend the night anywhere in the galaxy.

SO MANY OPTIONS! HOW COULD YOU POSSIBLY CHOOSE? —STAR-LORD

Literally any place besides this ship would suffice. —Gamora

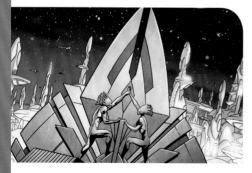

 ## TIPS FOR A FUN TRIP

DO: Visit as many Shi'ar worlds as possible. Few galactic empires have allowed such diversity to thrive within their control.

DON'T: Brag about your home world—unless you want it to be the next world annexed into the Shi'ar Empire!

BUT EARTH IS SO AWESOME!
—STAR-LORD

Says the guy who split that mudball the first chance he got. —Rocket

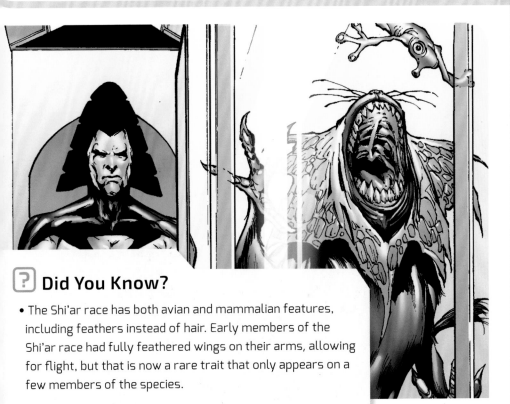

❓ Did You Know?

- The Shi'ar race has both avian and mammalian features, including feathers instead of hair. Early members of the Shi'ar race had fully feathered wings on their arms, allowing for flight, but that is now a rare trait that only appears on a few members of the species.

- Members of the Shi'ar Imperial Guard hail from hundreds of races within their empire, each bringing different physical abilities to the Guard's arsenal. Recently, the empire began recruiting members from select planets outside Shi'ar space to serve as ambassadors within the Guard.

- The current ruler of the Shi'ar Empire, Majestor Kallark, is one of the few non-Shi'ar to lead the empire. Before taking the throne, this Strontian earned the respect of his people as Gladiator, the praetor of the Imperial Guard.

GLADIATOR. A WARRIOR I CAN PROUDLY CALL MY EQUAL.

I AM GROOT.

HE DID NOT! IT WAS A DRAW!

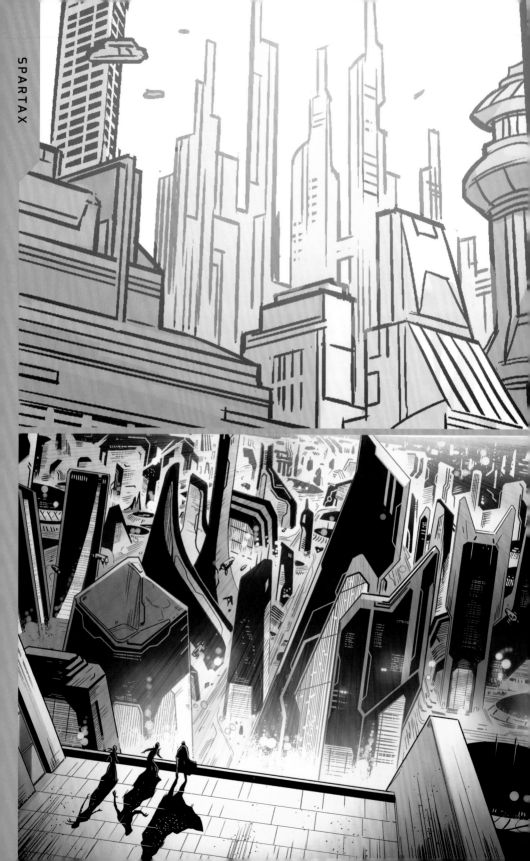

SPARTAX

LORDS OF THE STARS

Near the borders of the Shi'ar Empire exists a culture that brings together proud traditions and fresh beginnings. Under their new leadership, the Spartax system of planets has left its days of conquering behind and is forging ahead in bold new directions. *WITH OR WITHOUT ME . . . —STAR-LORD*

 ## HISTORY AND CULTURE

Evolutionary cousins of the Shi'ar, Spartax's denizens, the Spartoi, are a race of beings similar in appearance to the humans of Earth. Though Spartax was embroiled in many wars over the years, most notably with the Ariguan Confederacy, the planet has found itself in a period of (tenuous) peace with the neighboring empires.

But peace doesn't always equal happiness. The Spartoi recently became disenchanted with the harsh policies of their king, J'Son, who seemed to put his personal vendettas and ambitions above the welfare of his people. When it was broadcast live on the planet's royal propaganda network that J'Son had attempted to kill his son, his people staged a coup, removing him from the throne.

DAD IS TONS OF FUN AT FAMILY REUNIONS.

According to the planet's bylaws, its citizens were free to elect a new president of their choice—even if that person was not actively campaigning for the role. Their choice was nearly unanimous: Peter Quill, the half-human son of J'Son, better known throughout the universe as Star-Lord.

Never heard of him. —Rocket

AW, COME ON!

Following Quill's election, the Spartax Empire attracted a drastically increased level of attention from surrounding empires. Some looked to the new Spartax as a shining example of what a modern empire should be. Most simply wanted to see what would be its downfall: Quill's relative lack of leadership experience or his extensive list of cosmic-powered enemies.

I often wonder the exact same thing about the Guardians. —Gamora

After the planet was subjected to numerous brutal attacks, however, Quill was quickly removed from power and branded Spartax's public enemy number one.

AT LEAST I'M STILL NUMBER ONE AT SOMETHING! *I think we can all agree that, as a king, you were a big, steaming number two!*

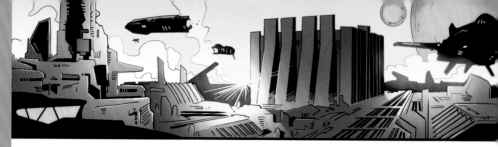

 ## ETIQUETTE

The Spartoi have a generally peaceful culture that has long relied on old formalities, both politically and publicly. However, the recently deposed king's easygoing attitude prompted many of Spartax's younger citizens to follow his lead, abandoning stuffy traditions for a more relaxed view of life. The Royal Guard may not be quite so laid-back, though, so be sure to behave with decorum, especially when visiting the capital city.

The king said I could put my krunaks on any surface I want. —Rocket

Another likely reason he is no longer in power. —Gamora

 ## WHAT TO WEAR

Dress casually. When visiting a planet where the former king rarely donned a clean T-shirt, there's no need to pack your finest evening wear.

I'M NOT SURE IF THE AUTHOR HATES ME OR IS IN LOVE WITH ME. —STAR-LORD

 ## SIGHTS AND ACTIVITIES

Spartax Royal Palace: The center of the empire, Spartax's Royal Palace is a wonder to behold. Much like the empire itself, the architecture of the palace seamlessly blends the classic and the modern into a style that works effortlessly. Beyond housing lush living quarters for the king, his Council of Ministers, and visiting dignitaries, the palace contains Spartax's primary government facilities. It also features several tranquil green spaces to provide an escape from the rigors of ruling an empire.

I AM GROOT.

OR TO DO THAT . . . I GUESS . . . IF THAT'S WHAT YOU'RE INTO . . .

 ## LODGING

The royal promenade in Spartax's capital city is lined with a number of the planet's finest hotels, ranging from affordable to opulent. With easy access to the planet's most popular dining and shopping venues, there's no reason to stay anywhere else.

UNLESS YOU HAPPEN TO KNOW A GUY AT THE PALACE WHO CAN HOOK YOU UP . . .

which, thanks to you, we don't.

TIPS FOR A FUN TRIP

DO: Take in some culture. Unlike the neighboring Shi'ar, the Spartoi are free to explore creative endeavors.

DON'T: Expect too much culture. Thanks to the most recent king's fascination with archaic Earth entertainment, many vendors replaced copies of Spartax's finest works with bootlegs of analog recordings and pixelated gaming programs.

DO: Order room service at the palace. Where else can you get fresh fleez'iks at three in the morning?

DON'T: ORDER THE FLEEZ'IKS. THEY WILL GIVE YOU GAS FOR WEEKS. —DRAX

SPARTAX

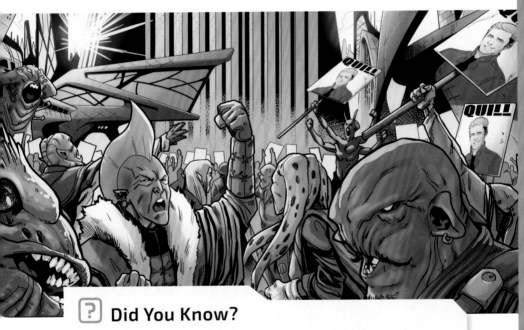

🄿 Did You Know?

- "Star-Lord" is actually a ceremonious title bestowed upon the person who is next in line for the throne of Spartax. The Star-Lord traditionally carries a one-of-a-kind element gun capable of firing blasts of earth, air, fire, and water.

 Better watch out, galaxy. Our leader has a water gun.

- Spartax once belonged to a secret council of galactic empires that included ambassadors from the Kree, the Shi'ar, the Badoon, and more. The council was originally formed to determine the place of Earth in the cosmic landscape but seemingly has since been disbanded.

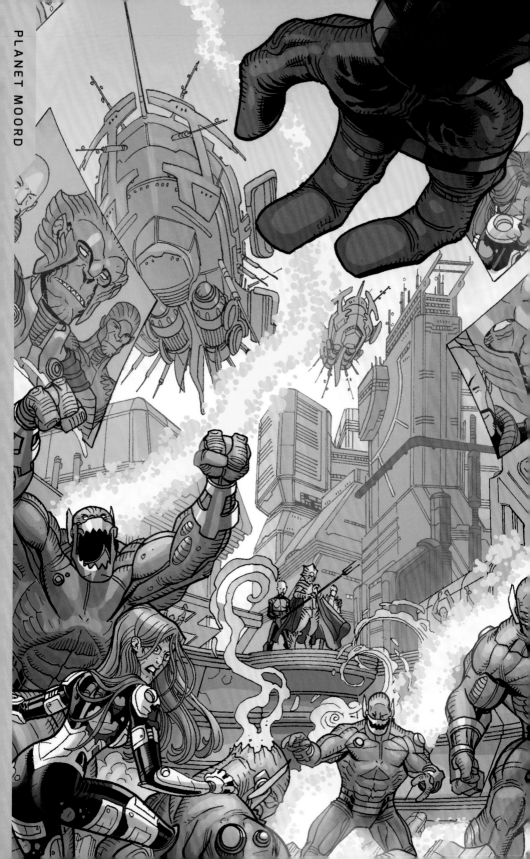

PLANET MOORD

THE BROTHERHOOD OF THE BADOON

Deep in the Lemora system sits the throneworld of one of the most despised empires in the universe—the Brotherhood of the Badoon. Few travelers come to Planet Moord of their own free will. Even fewer leave in one piece.

THOSE OF US WHO DO EARN THE RIGHT TO BRAG. —DRAX

 ## HISTORY AND CULTURE

Originating on the planet Lotiara in the Capella system, the Badoon are a reptilian race that has long been at war with almost every culture in the galaxy—including their own. A violent rift between males and females of the species led to brutal war between the sexes. *I BET THEY LEFT THE TOILET SEAT UP, DIDN'T THEY? —STAR-LORD*

Leaving the females behind on their home world, the Brotherhood of the Badoon departed to build a new home on Planet Moord. Here on this arid world, they spend their days plotting the destruction of their enemies. As it currently stands, almost all civilized cultures are on that list.

we made it on there TWICE! —Rocket

The Badoon are also notorious for an act they have not yet committed. According to a group of time-traveling heroes, the Brotherhood of the Badoon will conquer most of the galaxy in the thirty-first century. Because this future knowledge has been delivered to the present, all major galactic empires are keeping a close eye on the Badoon's activities.

Hey! I know her!

ETIQUETTE

Fight for your life. If you're on Planet Moord, it's either by accident or because you are a prisoner. Do not give up hope, even though your chance of survival is slim.

GETTING AROUND

Run. Hide. Then run some more.

OR STAND AND FIGHT, YOU WORTHLESS GLAKTAR! -DRAX

WHAT TO WEAR

Body armor, some sort of cloaking equipment, and a large arsenal of weapons.

SHOPPING AND ENTERTAINMENT

The Fighting Pits: When the Badoon do take prisoners, they keep them as slaves, either for trade or for personal entertainment. One of the most popular sports on the planet takes place in massive arenas where unwilling slaves are forced to fight to the death against Badoon warriors, genetically engineered monsters, and even each other. Volunteers are always welcome to participate.

Been there. Won that. —Gamora

? Did You Know?

- The Sisterhood of the Badoon are much more peaceful than their male counterparts. You would be far better off visiting Lotiara. Unless it is mating season.

- While female members of the Badoon species have similar reptilian characteristics to their male counterparts, they also grow hair on their scales, which covers most of their bodies.

- Members of both Badoon sexes only develop the urge to mate once in their lifetime, and when they do, the species' ancient mating rituals can become extremely violent. Because of this, the male Brotherhood of the Badoon have chosen to chemically suppress their mating instinct. *WHO NEEDS CHEMICAL SUPPRESSANTS WHEN YOU'VE GOT A PLANET FULL OF HAIRY LIZARD LADIES? -STAR-LORD*

CHITAURI PRIME

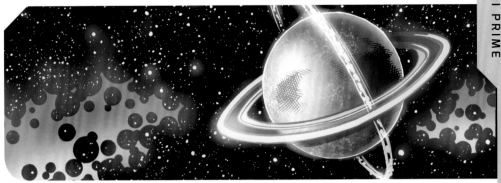

HARBINGERS OF DEATH

Chitauri Prime is the home of pain, suffering, and a race of warriors known for their unmatched brutality. *And the best grundleball team in the quadrant, the Chitauri Primates. —Rocket*

 ## HISTORY AND CULTURE

From a distance, Chitauri Prime is instantly recognizable for the unique pair of perpendicular rings orbiting it. On its surface, it is more recognizable as the home of a vile species hated and feared throughout existence.

TELL US HOW YOU REALLY FEEL . . . —STAR-LORD

The Chitauri are an alien race that exists for one reason alone—war. They're willing to destroy entire star systems to eliminate one enemy planet, and their ruthlessness knows no bounds. They view any world with valuable resources as theirs for the taking and the native culture of those planets as nothing more than an infestation.

Leading the nearly endless battalions of Chitauri soldiers are an elite class of warriors known as the Warbringers. These genetically enhanced warlords exhibit higher levels of strength, stamina, and durability than the standard Chitauri soldier. One Warbringer recently survived being thrust into the center of a star.

Not long ago, the Chitauri attempted to send a full armada to Earth as a proactive measure to prevent Earth's heroes from meddling in their universal conquests. Earth's heroes still managed to meddle, however. The Chitauri fleet was destroyed by a young Nova wielding the Ultimate Nullifier—a weapon capable of cosmic-scale destruction. *Good work, young Sam Alexander. —Gamora*

That same Nova drew even more attention when he came to Chitauri Prime on multiple occasions to free prisoners and rob the Chitauri Reserve Bank. The Chitauri have since turned their full attention to his home planet, Earth.

I take that back . . .

27

WHAT TO WEAR

It really doesn't matter what you wear to Chitauri Prime. It won't protect you from the savages who live there. If you must visit, do the rest of the universe a favor and strap a large thermonuclear device to your body armor. That way, when you are inevitably slaughtered by the Chitauri, at least you will take this miserable mudball down with you.

SHOPPING AND ENTERTAINMENT

Gladiatorial Games: For those who find the Badoon's slave pits too tame, the Chitauri have just the sport for you. These gladiatorial games are by far the most vicious in the galaxy, even surpassing the legendary tournaments that took place on the now-devoured planet Sakaar. If you're not brave enough to visit Chitauri Prime to view the games in person, they are broadcast live throughout the galaxy (fees may apply). *I KNOW WHAT WE ARE WATCHING THIS WEEKEND. —DRAX*

TIPS FOR A FUN TRIP

DO: Not go to Chitauri Prime. *See, now you made me WANNA go with*
DON'T: Go to Chitauri Prime. *your fancy reverse psycho-whatsit! —Rocket*

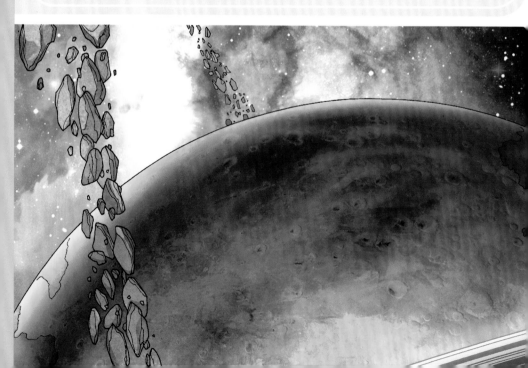

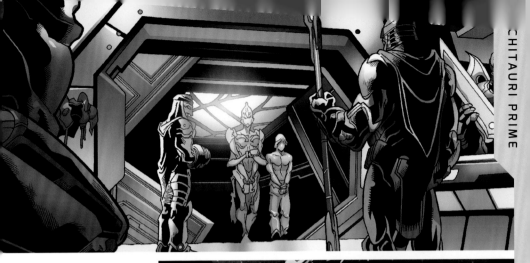

[?] Did You Know?

- The enormous Chitauri military frigates, known as Leviathans, are actually a hybrid of living matter and high technology. Each of these hulking beasts is able to carry hundreds of Chitauri soldiers and a full array of planet-smashing weapons.

- The Chitauri have recently developed a form of long-range teleportation that allows them to travel light-years in mere seconds. To rematerialize the traveler's body at the final destination, the teleportation process requires organic matter. That matter is usually unwillingly donated by any being unfortunate enough to be nearby.

- The Chitauri have 192 words for "hate."

That's impressive. I hate EVERYTHING, and I only have, like, 65. —Rocket

I. AM. GROOT.

Okay, make that 68.

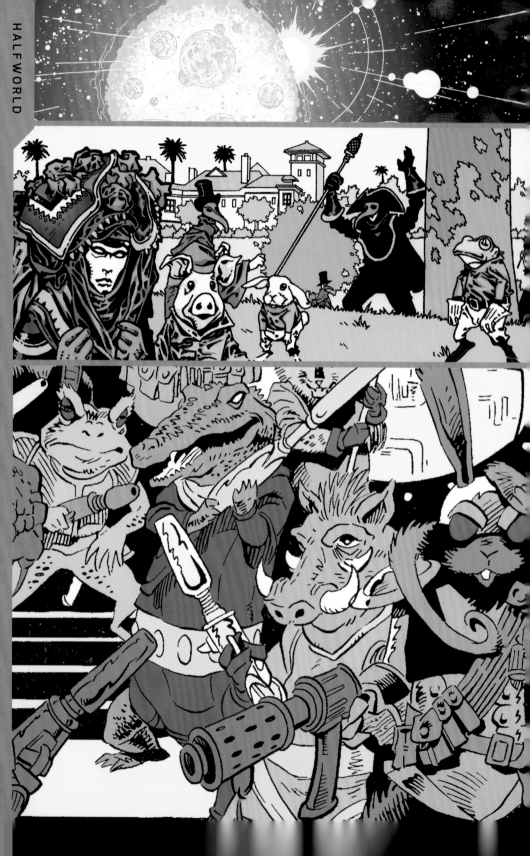

HALFWORLD

SAFE ASYLUM

Located in the Keystone Quadrant, past the Galacian Wall, is a planet called Halfworld. Named for its distinct division into two equal parts—one an industrial wasteland, the other a highly evolved paradise—Halfworld is known for its advanced technology and genetically enhanced animal population.

Home sweet home. **I AM GROOT.**

I know. I was being sarcastic. —Rocket

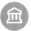 ## HISTORY AND CULTURE

Long ago, Halfworld was settled by a group of humanoid beings of unknown origin. Their goal was to build a safe haven where they could cure the members of their species ravaged by mental illness. The original treatment involved the use of both robotic caretakers and therapy animals used for companionship and comfort.

I do give great hugs.

Eventually, the planet's doctors were forced to abandon their efforts—and their patients. Before departing, they built the Galacian Wall—a huge force-field generator—both to prevent others from landing on Halfworld and to keep their patients safely on it.

Evolving beyond their original programming, the robots began to perform genetic experiments on the wide variety of animals serving as companions. This heightened the animals' intelligence and physical abilities, allowing them to communicate verbally, walk upright, and perform basic tasks.

If you call steering a spaceship safely through a meteor shower at light speed "basic"? Then, yeah, sure.

As the newly enhanced animals took over the care of the human patients, the robots departed to the opposite side of the planet and began developing new technology at an alarming rate, eventually rendering the region uninhabitable for nonmechanical beings due to pollutants from their manufacturing processes. *Did I mention some of the robots looked like clowns?*

As if this story was not disturbing enough already . . . —Gamora

After war broke out, the animals and robots of Halfworld eventually banded together to cure the humanoid population. Now, the cured humans and animals have rebuilt a society based on peaceful coexistence, while the robots continue their work in the far reaches of the planet. With the Galacian Wall now disabled, the inhabitants of Halfworld are free to come and go as they please.

And I was more than pleased to go. Far, far away.

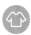 ## WHAT TO WEAR

On a planet populated with talking animals and robots, one might assume that clothing would be optional. Such is not the case. In fact, it is best to wear a strong carbon fiber mesh to repel any unexpected bites from the locals.

SIGHTS AND ACTIVITIES

Halfworld Asylum for the Criminally Insane: This massive multilevel structure was once home to the planet's humanoid population (also known as "Loonies"). The facility still houses dangerous criminals and those who could not be cured of their madness. Guided tours include a stop at the Admissions Ward, a shrine to the planet's original settlers. For an additional fee, guests can get the full Halfworld experience by spending the night in one of the Asylum's signature padded rooms.

SOUNDS LIKE YOU'D HAVE TO BE CRAZY TO STAY THERE! —STAR-LORD

SHOPPING AND ENTERTAINMENT

Halfworld is home to some of the universe's most skilled toy makers. The planet's enhanced animal population originally began developing these intricate playthings to keep the resident Loonies occupied and entertained. Each one is considered a handcrafted work of art.

That may randomly try to kill you. Fun for all ages! —Rocket

 TIPS FOR A FUN TRIP

DO: Treat Halfworld's animal population as equals. They may be cute and cuddly, but that doesn't make them any less deserving of your respect.
DON'T: Pet them. It's just demeaning. *Unless you're willing to pay up front. Then go ahead and demean me all you want.*

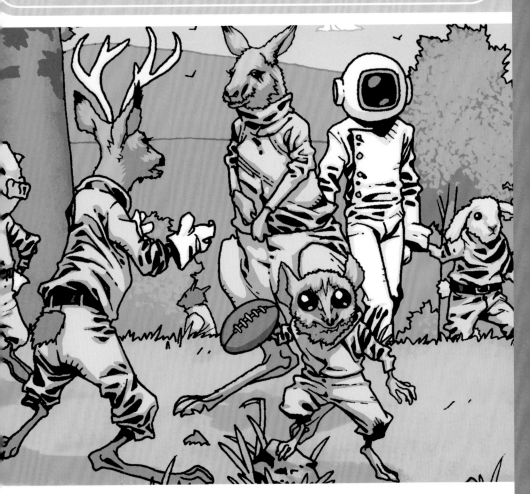

PLANET X

THEY ARE GROOT

Planet X is the capital of the Branch Worlds, inhabited by a race of sentient plant-based life forms known as the *Flora colossi*. The untouched beauty of this planet is perfect for any traveler looking for a rustic getaway.

 I AM GROOT.

🏛 HISTORY AND CULTURE

Planet X is a primarily peaceful society ruled by the Arbor Masters, the elder members of the *Flora colossi* species. With the help of their system's sun, the Arbor Masters pass along their combined generations of knowledge to the race's saplings in photonic form via photosynthesis.

To keep Planet X's ecosystem pristine, many of the young *Flora colossi* become fauna workers in the herbaceous habitats. They work together with the planet's maintenance mammals—small furry creatures devoted to tending to the biome's needs. Some young saplings have been known to hunt these tiny creatures for sport. I AM GROOT. Of course you didn't, you big softy! —Rocket

Though most of the planet remains in its natural state, untouched by advanced technology, the *Flora colossi* have built a number of space ports and their own fleet of ships capable of interdimensional travel and exploration.

👁 SIGHTS AND ACTIVITIES

Isle of Punishment: A stark contrast to the peaceful forests covering the rest of the planet, the Isle of Punishment is a desolate rock formation in one of Planet X's harshest climate zones. Members of the *Flora colossi* found guilty of crimes—including "tree-son"—are chained here as penance. The isle is guarded by hundreds of robotic birds armed with weapons systems capable of annihilating any prisoner who attempts escape.

I AM GROOT!
Yeah, that place was the worst.

35

 LODGING

The forests of Planet X provide a great deal of protection from the elements, allowing visitors the opportunity to experience nature up close and personal. Sleeping beneath the stars is perfectly acceptable, but a tent is recommended for those who desire a bit of privacy. After all, the trees do have eyes!

I AM GROOT . . .

 TIPS FOR A FUN TRIP

DO: Bring a translator device. Although their language is actually quite complex, the rigid wooden structure of the *Flora colossi* larynx only allows them to make a limited number of sounds. *I AM GROOT.*

Those are the ones! —Rocket

DON'T: Try to speak their language. A subtle difference in pronunciation could change a friendly greeting into an accidental declaration of war.

IF I HAD A CREDIT FOR EVERY WAR I HAVE ACCIDENTALLY STARTED . . . –DRAX

DO: Live off the woods. There are hundreds of varieties of edible berries growing naturally in the forests of Planet X, as well as a number of delicious nuts.

I AM GROOT.

Now that's just rude. Hilarious. But rude.

DON'T: Chop down those woods. No matter how cold the nights may get, using any world's indigenous people as kindling is a major faux pas.

Another reason Drax is a wanted man on so many planets. —Gamora

 Did You Know?

- In stark contrast to many other advanced civilizations, Planet X does not have an established electrical grid. However, the *Flora colossi* are capable of generating bioluminescent spores that provide sufficient light for travel through even the deepest forests of their home world.

- Like nonsentient trees on other planets, a damaged *Flora colossus* can regrow injured limbs. Mature members of the species can regenerate their entire forms from a single splinter.

- Planet X's maintenance mammals have long maintained a symbiotic relationship with the *Flora colossi*, but they recently formed the Undergrowth Resistance—a group dedicated to protecting the rights of the planet's working-class creatures.

PLANET OF THE SYMBIOTES

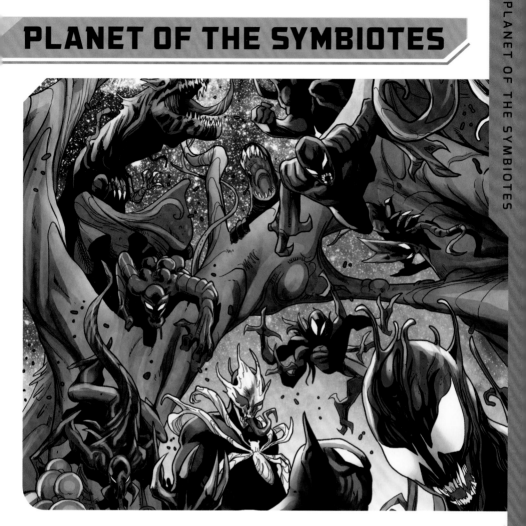

AGENTS OF THE COSMOS

Far beyond the borders of most known maps is a planet unlike any other in the galaxy. This unnamed world is teeming with strange symbiotic creatures eager to bond with intelligent beings from visiting races. If you can find your way here, get ready to make a new best friend!

I AM GROOT.
Aw, right back at ya, amigo!
—Rocket

 ## HISTORY AND CULTURE

Outside the boundaries of charted space lies the planet of the Klyntar—a species with fluid physiology and a heightened consciousness. Because of their lack of solid physical form, the Klyntar have become dependent upon symbiotic relationships with organisms from other civilizations. Once bonded to a suitable host, these "agents of the cosmos" are able to leave their home planet to assist other races in spreading peace and prosperity.

On their home planet, the Klyntar are able to communicate telepathically via a communal hivemind. However, the further an agent ventures from the planet, the weaker their connection becomes. This allows the Klyntar symbiote to become more susceptible to the influences of its host organism. Because of this delicate equilibrium, it is important that the selected host is perfectly balanced, both physically and morally. *SOUNDS JUST LIKE MY GOOD FRIEND VENOM!*
—STAR-LORD

Despite their noble intent as a species, the Klyntar and their planet are feared by many galactic civilizations. This is because corruption can occur when a Klyntar symbiote bonds itself to an unworthy host. These aggressive unions have often resulted in chaos, death, and destruction for anyone who crosses the pair's path.

SOUNDS LIKE <u>MY</u> GOOD FRIEND VENOM . . . —DRAX

Some corruption can be repaired, either by severing the Klyntar's bond with its negative host influence or by returning it to its home planet for reconnection to the hivemind. This restorative process purges all toxins and abnormalities from the Klyntar and its host, making way for a union with renewed clarity and purity.

They may look slimy and gross, but ten minutes in one of those symbiotes feels better than a week at the flarkin' spa! —Rocket

GETTING AROUND

The planet itself is virtually impossible to find. The Klyntar have intentionally kept it secluded over the eons to avoid external corruption. If you need to venture here, it is recommended that you travel with a Klyntar symbiote aboard your ship. The symbiote can sense the proximity of its home planet and will make every effort to guide you safely to its home. *AND BY THAT THEY MEAN IT WILL TAKE OVER YOUR BODY AND DRIVE YOU THERE AGAINST YOUR WILL.*

ETIQUETTE

The Klyntar are generally peaceful, but they do have a tendency to invade the personal space of their guests. It is perfectly acceptable to refuse any physical connections with them. If their tendrils are still too close for comfort, the species is susceptible to both fire and sonic devices—but use these personal protection methods only as a last resort, as it could potentially drive them into a frenzy.

WHAT TO WEAR

Though the Klyntar would likely prefer that you wore one of them, not every visitor is ready for the commitment of a symbiotic union. If you feel the need to explore the planet from outside the confines of your spacecraft, you will likely want to don a self-contained flight suit with no open seams to prevent any undesired bonding.

"Undesired Bonding" should be the title of our team's biography.
—Gamora

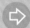 TIPS FOR A FUN TRIP

DO: Open your mind. Connecting to the Klyntar hivemind may seem frightening, but it can be a very freeing and enlightening experience for those willing to step beyond their comfort zone.

DON'T: Be offended if you are not chosen to pair with a Klyntar symbiote. They are very selective when it comes to hosts. It is the highest honor to be deemed worthy of bonding, but simply viewing these unique creatures in their natural habitat can be an equally thrilling experience—with far fewer long-term obligations attached.

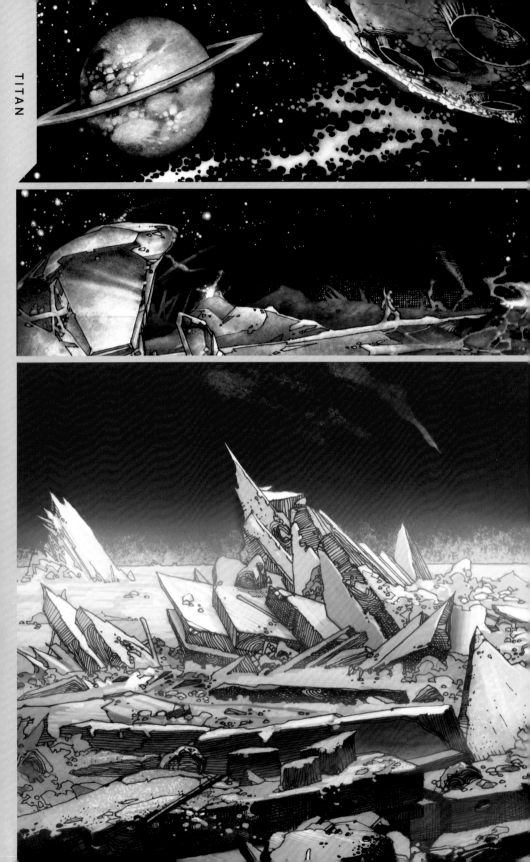

TITAN

TITAN

THE BIRTHPLACE OF DEATH

This unassuming moon in the Sol System was once home to a thriving colony of brilliant scientists and scholars. Today, it is little more than a monument to death forged by its most notorious citizen—Thanos the Mad Titan.

I AM GROOT.

That monster is NOT my father. —Gamora

HISTORY AND CULTURE

The Eternals are an ancient offshoot of humanity that evolved from experiments by a race of ancient godlike beings known as the Celestials. When a rift formed between two factions of Eternals on Earth, a civil war erupted. Those Eternals on the losing side of the conflict were exiled into space and eventually settled on Saturn's largest moon, Titan. *With 62 Saturnian moons, it must've been hard to settle. Me, I've always been a Rhea guy myself. —Rocket*

Here, with the help of Kree technology found on a Uranian outpost, the Eternals built a new civilization. When war broke out on Titan, though, their population was decimated. The sole survivor, Sui-San, was soon joined by another Eternal from Earth named A'lars. Together they repopulated the colony on Titan. But as they restored life to the moon, they were unaware that they were bringing death to the universe in the form of their son, Thanos.

For ages, the Eternal colony on Titan thrived, first in the caves and, eventually, on the moon's surface. With an artificial environment and advanced technological systems, Titan became known across the universe as a place for study and meditation. Thanos ended that when he returned home to slaughter his people and destroy their civilization. A'lars was one of the only Eternals who survived the onslaught, spared by his son and left to face his failures alone.

AND I THOUGHT GAMORA HAD DADDY ISSUES . . . —STAR-LORD

From that point forward, A'lars focused his great scientific knowledge in an effort to redeem himself and his fallen people by creating the means to destroy Thanos once and for all. *AND THUS DRAX THE DESTROYER WAS BORN! —DRAX*

WHAT TO WEAR

Titan's artificial atmosphere has almost completely dissipated, making a space suit with life support essential for exploration on the moon's surface.

 ## SIGHTS AND ACTIVITIES

Captain Marvel Memorial: Before the entire colony of Titan became a graveyard, there stood a memorial to one of the greatest heroes the universe has ever known—Mar-Vell, the Kree soldier who served as the original Captain Marvel. After his untimely death, Mar-Vell's remains were laid to rest on Titan, and a monument was constructed in his honor. His burial site can still be visited by those wishing to pay their respects.

Or you can just wait till he comes back to life. Again. —Rocket

 ## LODGING

Though most of Titan is in ruins, the caves where the colony originated are still accessible and may have trapped some of the artificial atmosphere created by the Eternals' technology. Long stays are not recommended, but this could be a great pit stop on the long journey to or from Earth.

[?] Did You Know?

• The biosphere on Titan was maintained by an artificially intelligent supercomputer named ISAAC—the Integral Synaptic Anti-Anionic Computer. ISAAC's main programming directives have been changed and corrupted on numerous occasions throughout the history of the Titan colony.

• In the centuries between the founding of Titan and the birth of Thanos, there was not one recorded murder in the colony. In fact, it is said the concept of murder did not even exist amongst Titan's people.

Thanos certainly changed that. —Gamora

• Rumors suggest that Thanos returns to the city of his birth once every solar cycle. It is unknown whether he makes the sojourn to Titan to gloat over his victory or to remind himself of who he once was.

WE CAN WAIT FOR HIM THERE AND END HIS REIGN OF TERROR! —DRAX

A yearlong stakeout on a graveyard moon? What a vacation!

EGO

THE LIVING PLANET

In the depths of the universe is a galaxy unlike any other. A bioverse teeming with life but home to only one sentient creature—the massive, planet-sized Ego.

Turn the page. We've already got too many planet-sized egos on this ship.

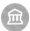 ## HISTORY AND CULTURE

Ego is the sole intelligent life form to emerge from the bioverse known as the Black Galaxy. *How many stupid life-forms came from there?*

 This monolithic creature is able to manipulate his mass in a number of ways, manifesting giant tentacles and even creating nonsentient life forms on the surface of his planetary body. Should unwanted visitors land on him, Ego is able to generate "Anti-Bodies," humanoid creations designed to eliminate the foreign matter.

 Unlike most planet-sized objects, Ego does not orbit a star. Instead, he has learned how to propel his mass freely through the galaxy in hopes of discovering other creatures like him.

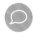 ## ETIQUETTE

Ego does not appreciate visitors and, quite frankly, is usually not terribly pleasant to be around. *Exterminate an infestation of giant head lice for him, though, and you'll be chums for life!*

DINING AND NIGHTLIFE

You're less likely to dine on Ego than Ego is to dine on you.

BUT IF YOU'RE REALLY DESPERATE, THERE MIGHT BE SOME GIANT CRUMBS LEFT IN THAT 100-MILE MUSTACHE. -STAR-LORD

TIPS FOR A FUN TRIP

DO: Take the time to ask questions. Few beings have seen as much of the universe as Ego. And, though he may seem imposing at first, if you catch him in the right mood, he can be a good conversationalist.

DON'T: Take a sample from Ego's surface. Even though it may seem like a great souvenir, there's a chance it could bond to your home world and turn it into a giant Ego clone!

? Did You Know?

- Because sound cannot travel through the vacuum of space, Ego communicates telepathically.

- Ego is one of the few planets to successfully fend off Galactus, the Devourer of Worlds.

- Before Ego mastered self-propulsion, he traveled through space using a giant thruster attached to his south pole.

 I AM GROOT.

 I was totally gonna say that! —Rocket

KNOWHERE

OASIS ON THE EDGE OF SPACE

When a universe is filled with so many wondrous places to explore, it can be easy to forget how much empty space actually lies between each location. A traveler can often venture for light-years without encountering any signs of life, a phenomenon that becomes increasingly more likely the closer one gets to the edge of the known universe. *SPACE . . . THE FINAL FRONTIER . . . —STAR-LORD*

I don't get it. Is that another stupid Earth thing, Quill? —Rocket

Fortunately, right when it seems that you have traveled a little too close to the border of your map, there is one final destination on the horizon—a place where travelers from countless worlds gather to refuel their ships, refill their bellies, and, perhaps, reconsider their paths. *Something that I do almost every day . . .*

YOU KNOW THE REST OF US CAN READ THIS, RIGHT, GAMORA? —Gamora

Part research base, part intergalactic way station, part seedy nightclub, this last outpost—which happens to be constructed inside the severed head of an enormous ancient alien—is unlike any other locale in the vast universe that it orbits. It is because of this that it has truly earned its name: Knowhere.

45

HISTORY AND CULTURE

Few living creatures can ever hope to comprehend the godlike power of the colossal cosmic beings known as the Celestials. Even fewer can fathom what it would take to decapitate one of these star-born giants. The thought alone could drive the most learned philosophers and scientists in the galaxy to madness. Perhaps even more disturbing, however, is the fact that other beings eventually deemed it acceptable to inhabit this doomed Celestial's severed skull.

I AM GROOT. I hear ya, pal. It may be gross, but it's home. —Rocke

Hardly any solid facts exist that shed light on Knowhere's true origins. Some say that the colony was created solely for the purpose of scientific observation. Others suggest that the deceased Celestial's brain matter was rich with rare elements that could be mined for profit. Whatever the case may be, it is unlikely that the first being to enter the expanses of Knowhere could have predicted the unique culture that would soon spring to life within.

"UNIQUE" IS ONE WORD FOR IT. I MIGHT HAVE GONE WITH "DANGEROUS" OR "VOLATILE." -STAR-LORD OR "DELIGHTFUL." -DRA;

Over the eons, the civilization inside Knowhere has been enriched by every new species that has come to call it home. And while travelers have come and gone, they have each contributed to making Knowhere one of the universe's most culturally diverse destinations. Where else can one dine on Skrull delicacies while reading archaic Kree texts downloaded directly from a secondhand Rigellian recorder? Here, every walk of life is represented, including some that are less savory than others—so be sure to hold on to your credits!

I have begun to doubt the validity of this text.

There is NO SUCH THING as a "Skrull delicacy." —Gamora

ETIQUETTE

Because of Knowhere's expansive cultural makeup, customs and traditions can often be difficult to navigate. A simple gesture that may be considered a common courtesy to the Xandarian may actually deeply offend a Badoon, so it is best to be aware of your surroundings and fellow travelers at all times. *I only got one simple gesture for the Badoon—and it ain't a common courtesy!*

With thousands of alien races represented on Knowhere, one cannot be expected to cater to all of their varied social graces. When things get lost in translation, misunderstandings are bound to happen. Luckily, there is one common thread that ties together beings from every culture: currency. Virtually any dispute, no matter the cause, can be settled for the right amount.

I FIND THAT ALL RACES UNDERSTAND THE TIP OF A KNIFE TO THEIR THROATS QUITE CLEARLY.

GETTING AROUND

The corridors of Knowhere tend to be rather confusing and extremely crowded at all hours, so having a predetermined plan for traveling through the station's labyrinthine layout is a must. *Rocket's Travel Tip #47: If you hear screams or explosions, run the other way! And miss all the fun?*

A number of for-hire transportation services are available within the more heavily traveled regions of Knowhere, especially in the Marketplace, but none of them are licensed or regulated, so proceed with caution.

WHAT THEY'RE TRYING TO SAY HERE, KIDS, IS NEVER TAKE RIDES FROM DIRE WRAITHS.

Knowhere's infrastructure has also been fitted with a wide network of pneumatic lifts that can rapidly transport individuals between the station's numerous levels and regions. While most of the station is open to the public at all times, there are some zones considered off-limits to visitors, including the central security station. Even restricted areas can be made accessible, though, thanks to regular tours given by Knowhere's own Chief of Security, Cosmo. (Background checks are required.) *Unless you bribe him with a squeaky toy or a bone . . . —Rocket*

A more unusual transportation option is housed within Knowhere's lower levels: the Continuum Cortex. Wired directly into the brain stem of Knowhere's Celestial host, the Cortex taps into interdimensional energies and allows individuals to be instantly teleported to any destination in the known universe—and beyond! With the aid of a special bracelet, available for purchase at many shops in the Marketplace, the voyage can be made into a round trip. The Continuum Cortex can be an extremely useful way to escape from the overwhelming hustle and bustle of Knowhere's daily life.

OR TO ESCAPE FROM A PACK OF BLOODTHIRSTY INTERGALACTIC BOUNTY HUNTERS. –STAR-LORD

IF YOU ARE A COWARD. –DRAX

I AM GROOT.

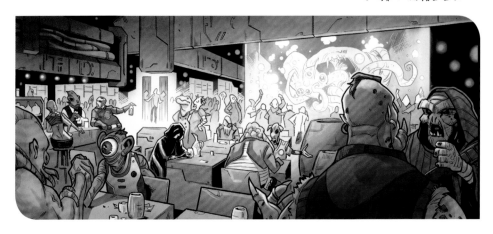

 ## WHAT TO WEAR

The depths of space can be a cold, unforgiving environment. While the exterior of Knowhere is heavily shielded by Celestial armor plating and the station's interior climate is maintained at a comfortable level, there is still a bit of a chill in the air, most likely from the near-constant opening and closing of shuttle bays as travelers come and go. Dress accordingly. *I find the chill of space quite comforting. —Gamora*

You would.

Since Knowhere is recognized as a safe haven for intergalactic refugees and neutral ground for trade, the station has occasionally found itself under attack by various alien species with nefarious agendas. Because of this, there is an ever-present possibility of sudden hull breaches that could lead to internal atmospheric decompression. Though this is unlikely, it is still recommended that all visitors pack an emergency space suit with built-in life-support features.

SINCE WE MOVED IN, THIS HAPPENS AT LEAST ONCE A WEEK.

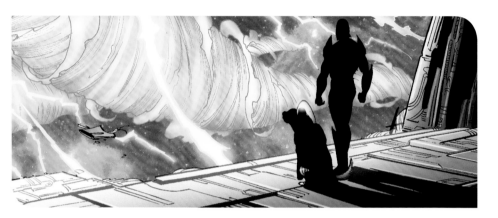

 ## SIGHTS AND ACTIVITIES

Observation Deck: While the wonders inside Knowhere are plentiful and glorious to behold, there is no sight more fascinating than the galactic void beyond the station's boundaries. Situated along a rift in space/time, Knowhere has lured just as many quantum scientists and universal observers as it has intergalactic travelers and sightseers. No trip to Knowhere would be complete without a visit to the Observation Deck, where you can peer deep into the cold abyss. *Or just gaze into Gamora's eyes during a date. Brrrr!*

 ## SHOPPING AND ENTERTAINMENT

The Marketplace: Populating an entire quadrant of Knowhere, the Marketplace is where most of the station's daily—and nightly—activity occurs. Open around the clock, this vibrant collection of independent shops and eateries is the perfect place to try something new or hunt down something old. With a near-infinite selection of rare items collected from across the universe—not all of them legal on every planet—the Marketplace is a must for any traveler seeking the ultimate souvenir. *VISIT FRUNTA'S FOR THE SHARPEST WEAPONS. TELL THEM DRAX SENT YOU. WATCH THEM TREMBLE.*

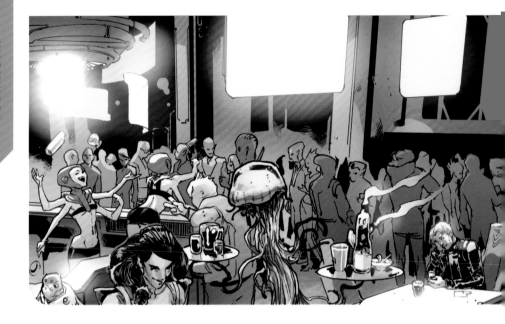

DINING AND NIGHTLIFE

Starlin's Bar: A hidden gem located in the Marketplace, Starlin's Bar is considered the birthplace of the modern cosmic cocktail. Filled with a colorful cast of regulars who have been drinking here for decades, this eclectic establishment has managed to maintain its rustic charm, despite the ever-increasing number of boisterous visitors who threaten to turn this classic "hole in the wall" into yet another tourist trap. I PAID TO HAVE THAT HOLE IN THE WALL FIXED. I MUST SPEAK WITH THE MANAGER UPON OUR NEXT VISIT. –DR

The establishment's signature drink, the Mad Titan, is a mixture of six brightly colored alien liquors that, when imbibed, are said to grant a feeling of omnipotence. It is served in a collectible "Infinity Goblet" for a whopping 91 credits.

JIM THE BARTENDER EVEN NAMED A DRINK AFTER ROCKET! –STAR-LORD

It tastes like dandruff and gunpowder. –Gamora

Yeah... That's why they named it after me. What's your point? —Rocke

LODGING

Finding a decent hotel room in Knowhere can be a bigger gamble than visiting the station's underground casinos. What may sound like a luxurious getaway when booking often ends up being nothing more than a dirty mattress in a Sneeper's guest bedroom. *BUT, REALLY, WHO HASN'T WOKEN UP NEXT TO A SNEEPER EVERY NOW AND THEN?* I ~~AM~~ GROOT.

Even Knowhere's living quarters for visiting delegates are buried deep within the station's sublevels and lack the charm and amenities that most civilized planet-hoppers have come to expect. A handful of four-star establishments have recently been constructed, but they tend to be as overbooked as they are overpriced. Travelers looking for the comforts of home might be better off packing an extra pillow and sleeping in their ship's cargo bay.

BEDS ARE FOR THE SOFT AND WEAK. I WILL SLEEP ONLY WHEN ALL OF MY ENEMIES HAVE PERISHED BY MY HAND.

 TIPS FOR A FUN TRIP

DO: Try something new. You'll never find such a wide variety of unique souvenirs and unusual foods anywhere else in the known universe.

DON'T: Try the street vendor glarkin, no matter how good it may smell.

DO: Talk to the locals. They are your surest bet for finding Knowhere's hottest spots and the freshest trends.

DON'T: Argue with the locals. There's a reason Knowhere's inhabitants live out on the edge of the universe. For some of them, it's not a choice.

DO: Give all your credits to the adorable little furry guy with the hilariously oversized gun!

DON'T: Call him a raccoon unless you want to discover how his gun works.

 Did You Know?

- Knowhere has hosted thousands of rare and unusual species but has managed to avoid Brood infestation during its entire recorded history.

- The Continuum Cortex not only is capable of transporting beings anywhere in the universe but also is rumored to be able to send them anywhere in time as well!

- It is not uncommon for beings of great cosmic power to visit Knowhere during their travels. Be on the lookout for spacefaring celebrities like Nova, the Silver Surfer, and even members of the Avengers!

Seriously? We have a flarkin' base on Knowhere, and we don't even get a mention?! Come on!

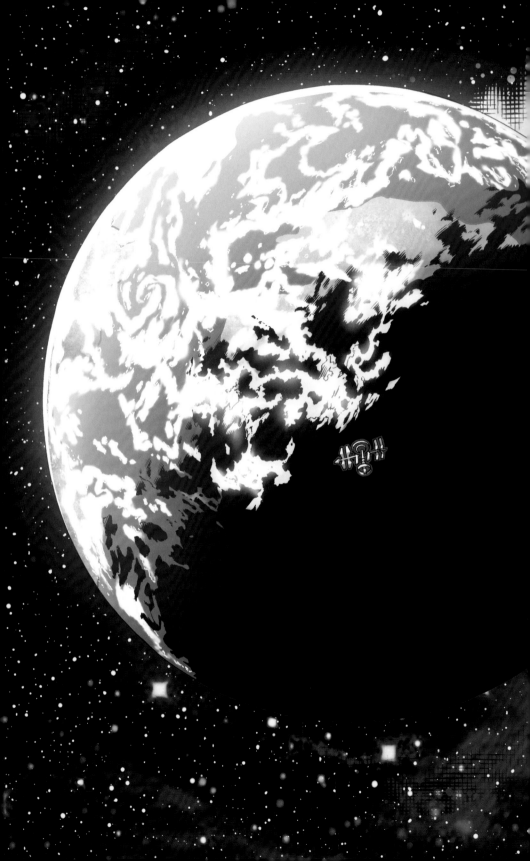

EARTH

THE NEW CENTER OF THE UNIVERSE?

For millennia, a small blue sphere in the Sol System has been an oasis for intergalactic travelers. Earth is the perfect vacation spot for any species in the universe seeking a moderate climate, an oxygen-rich atmosphere, abundant fresh water, and a naïve populace quick to worship them as gods.

Countless civilizations—from the Kree to the Celestials—have visited this planet to put their own unique stamp on the development of its dominant species, the human. *ALSO, APPARENTLY, TO KNOCK UP MY MOM. -STAR-LORD*

That IS a unique stamp . . . —Gamora

But the perception of Earth as a quaint backwater lagging eons behind other spacefaring civilizations is rapidly changing. It has been less than a century since the first citizen of Earth ventured into space, but the mark that humanity has left on the cosmos has already proven to be substantial. Earth's bold travelers have been fearless in tackling intergalactic conflicts far beyond their scope of understanding, often emerging triumphant where other civilizations have failed.

SEE THAT? THEY SAID WE'RE "BOLD" AND "FEARLESS."

You sure they didn't mean "bald" and "furless"? -Rocket

When any young civilization makes such a large impact in such a short time, it is certain to draw the attention of long-established cultures. Because of this, interstellar travel to Earth has increased rapidly over the last few decades—albeit, with mixed results. Because the majority of Earth's populace is still new to the concept of life beyond their own orbit, they can tend to be a little narrow-minded and xenophobic. A nonhumanoid species going on a peaceful vacation to Earth may find that its presence is interpreted as an attempted invasion. (Perhaps this ignorance should be unsurprising given that most humans don't even bother to learn the languages spoken in neighboring regions of their own planet). *I AM GROOT.*

POINT TAKEN.

Earth certainly has a long way to go, but as seasoned travelers of the spaceways, we would be remiss if we did not take the time to applaud how far it has already come. See for yourself some of the wonders that Earth has to offer . . .

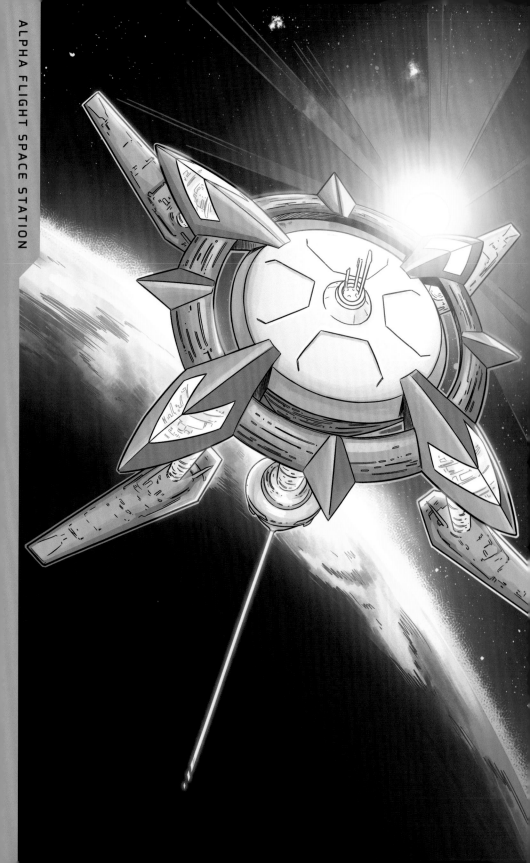

ALPHA FLIGHT SPACE STATION

EARTH'S WELCOMING COMMITTEE

Planning on taking a trip to Earth? There's a new mandatory detour on your journey—Alpha Flight Space Station. Alpha Flight is the newly launched, low-orbital space station that serves as Earth's first line of defense against alien hostiles and cosmic threats. Unless you make a pit stop here first, your visit to Earth may end before it begins.

At least they have vending machines and a bathroom. —Rocket

 ## HISTORY AND CULTURE

After recent attacks on the planet by hostile extraterrestrials, Earth's governments have upgraded the planet's external defenses in order to more easily identify and intercept potential threats. Even the friendliest of alien species must now pass through clearance protocols before making Earthfall.

THEY DARE QUESTION THE MOTIVES OF DRAX THE DESTROYER? —DRAX

I THINK YOUR MOTIVES ARE RIGHT THERE IN YOUR NAME. —STAR-LORD

To house this initiative, Alpha Flight Space Station was deployed 250 kilometers above the planet. The station is locked in geosynchronous orbit directly above the Triskelion in New York City, the building that serves as home to the Alpha Flight's ground crew.

Manned by a multinational team of scientists, technicians, and Super Heroes, Alpha Flight Space Station is prepared to instantaneously engage any cosmic threat approaching Earth's atmosphere.

And, knowing humans, they'll likely fire at you before they determine if you are actually a threat. —Gamora

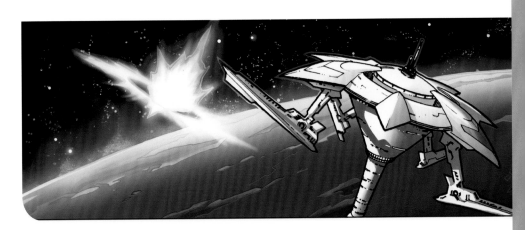

 ## GETTING AROUND

Alpha Flight Space Station has several docking bays for easy access by spacecraft of all models. Once your ship is cleared by the station's crew, getting on board is a breeze. The station itself is easily traversable on foot.

The station offers a direct link to Earth below via a high-speed energy elevator called the Aerolith. When activated, the Aerolith can transport passengers to and from the Triskelion in a matter of minutes.

Should an emergency arise that requires personnel evacuation, life-support pods are available near the emergency airlock to shuttle crew and visitors safely back to Earth. If all life-support pods are taken or compromised, specialized space suits are available to withstand a "halo drop"—a high-velocity launch into Earth's atmosphere via the station's airlocks. Parachutes will deploy upon final reentry. Forget the life pods. Halo drop me! —Rocket

With pleasure. —Gamor

 ## WHAT TO WEAR

While the entire Alpha Flight team wears easy-to-identify jumpsuits, visitors are not required to adhere to any dress code. Alpha Flight members respect the traditions and customs of visitors from the entire universe's many species. I AM GROOT.

You WOULD look good in one of those.

 ## LODGING

Alpha Flight Space Station is more than just a defense command center. For all who have signed on to protect the planet, it is also home. To keep the crew—and any extraterrestrial visitors—comfortable, the station offers full amenities, including a spa, gym, and meditation room.

AND A CARGO HOLD FULL OF INSANELY POWERFUL WEAPONS. —DRAX

WHICH WE TOTALLY DID NOT STEAL. —STAR-LORD

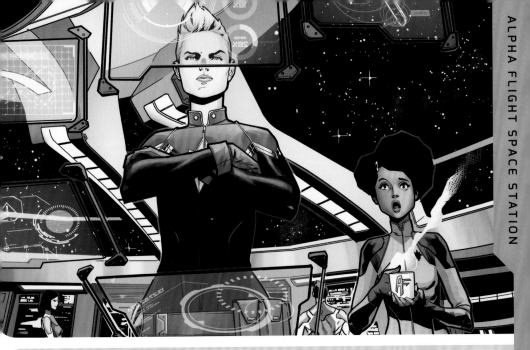

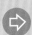 **TIPS FOR A FUN TRIP**

DO: Bring valid identification and clearance codes. The last thing you want is to be stuck on the station for hours filling out paperwork.

DON'T: Avoid protocol. The station's state-of-the-art technology is alarmingly efficient at detecting even the most unassuming arrivals. If you think you can bypass the check-in procedure by cloaking your ship or employing evasive maneuvers, you're wrong. Don't make things harder than they need to be.

But that's what I do best!

? Did You Know?

• Alpha Flight's leader is a hero well recognized across the universe—the current Captain Marvel. A human imbued with Kree powers, Carol Danvers has made a name for herself traveling the galaxy protecting innocent civilizations from certain doom. She has earned the respect of countless cultures, both on her own and as a member of teams such as the Avengers, the Starjammers, and, most recently, the Ultimates.

AND THE GUARDIANS! IT'S LIKE THEY'RE GOING OUT OF THEIR WAY NOT TO MENTION US. DID WE STEAL THE AUTHOR'S SHIP OR SOMETHING?

EARTH: NEW YORK CITY

THE SELF-DECLARED CENTER OF THE UNIVERSE

The landmasses of Earth are divided into many unique regions, each with its own customs and traditions. Yet there is one singular destination in which the greatest aspects of nearly all of Earth's cultures are represented: *Branson, Missouri! —Rocket*
New York City. *That was my second guess.*

Located on the eastern coast of the United States of America, this major metropolis provides a cross section of everything Earth has to offer. Everywhere you look, you're bound to see something breathtaking—from iconic landmarks such as the Baxter Building to legendary heroes like Spider-Man.

If you're on a tight schedule and can only make one stop on Earth, this is the city for you.

IF YOU'RE ON A TIGHT BUDGET, NOT SO MUCH. –STAR-LORD

 ## HISTORY AND CULTURE

New York City had rather humble beginnings as a trading post. How appropriate, then, that a few short centuries later the island of Manhattan evolved into the epicenter of Earth business and commerce. The city's nearly 8.4 million human inhabitants work long hours to be able to afford small, compartmentalized living quarters often no larger than a pan-galactic shipping container.

And you don't wanna know where they make the 16 million rodents live!

Despite the less-than-favorable conditions for its many inhabitants, New York City does house some of Earth's finest works of art. Its museums and theaters are renowned across the world and draw millions of tourists into the city each year. Whether it's an award-winning Broadway musical or an intimate Lila Cheney acoustic performance at a small downtown club, there is something in New York to appeal to everyone.

THE ONLY SOUNDS I WISH TO HEAR ARE THE SCREAMS OF THE GUILTY. –DRAX

THEN YOU WILL LOVE THE STOCK EXCHANGE.

If you need an escape from the city's often oppressive urban intensity, you'll be pleased to hear that more than 6 percent of Manhattan is devoted to parks and green spaces. Here, even Earth's most cutthroat businessmen can find a peaceful place to relax and let out their inner love of nature!

I AM GROOT?!

I am certain they did not mean it like THAT. –Gamora

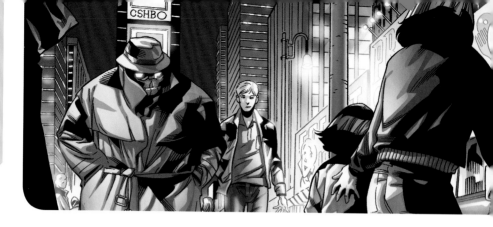

 ## ETIQUETTE

New Yorkers come from a variety of backgrounds, so customs may vary. Although the city's diverse population has resulted in general acceptance and tolerance for the different members of their own species, most humans are still wary—and sometimes even terrified—of any beings outwardly different from them. Therefore, unless you are a shape-shifter capable of taking human form, we would highly recommend bringing an image inducer to disguise yourself as human. If not, then cloaking of some sort might be your best option if you do not want to be confronted by the Avengers or chased off the island by an angry mob.

Why can't I get chased by a cheery mob for once? —Rocket

 ## GETTING AROUND

Personal aircraft of any variety are not permitted within the confines of the city, so most travel in New York is accomplished on the ground level—or below. Beneath the streets of New York lies a tightly woven network of tunnels housing the city's public transit system. These trains, called the "subway," are an affordable option for traversing the city if you can understand their complex schedules and routes. If you would prefer to stay above ground, New York's streets are clogged with an endless yellow sea of vehicles-for-hire called "taxis," ready to take you to your destination at the slowest possible pace for the highest possible price.

If you are a species capable of flight, this is one of the few Earth cities where you can use those abilities without instantly being shot down. It is not uncommon for Earth's heroes and villains to combat the congestion of city traffic by taking to the skies.

Perhaps the best mode of transportation is self-propulsion. Walking through the city not only provides great exercise but also allows you the chance to slow down, take in your surroundings, and even locate some of the city's hidden gems.

GEMS? THIS EXPLAINS WHY THANOS HAS ATTACKED THE CITY SO MANY TIMES! —DRAX

WHAT TO WEAR

New York is viewed as one of Earth's style centers, and the clothing seen on its streets can be as varied as that displayed on its fashion runways. From businessmen in million-dollar suits to tourists in casual attire, proper clothing is completely determined by the occasion. Even gaudy stretch fabrics have become acceptable, thanks to the city's abundant superhuman community (and the countless Super Hero impersonators swarming the city's tourist districts).

The city is prone to extreme temperatures depending on the season, so be sure to check planetary forecasts and pack accordingly.

Despite what relaxing attitudes may suggest, it will never be acceptable to wear blue jeans to a Broadway show.

I didn't wear blue jeans, but they still kicked me out of "The Lion King."

You weren't wearing ANY pants, Rocket. —Gamora

Neither was the lion . . .

SIGHTS AND ACTIVITIES

Stark Tower: One of the tallest buildings in the city, the new Stark Tower can be viewed either as a shining beacon of Earth's technological achievements or a monument to one man's already monumental ego. Either way, there is no denying that Tony Stark, better known across the galaxy as Iron Man, has had a huge hand in shaping Earth's reputation in the intergalactic community. Although this is just one of the many buildings across the planet housing branches of his newest company, Stark Technologies, this is Stark's flagship location and, undeniably, the most impressive in his real-estate portfolio. The building houses more than just his professional ventures, though. Stark often stays in the building's luxurious penthouse suite and creates his trademark suits of armor in its state-of-the-art workshop. Although the company has recently stopped giving tours as a result of repeated attempts at corporate sabotage, that doesn't stop tourists from crowding into the lobby in the hope that Tony Stark might come down from his tower to greet his adoring public.

Save yourself the time. Stark cares nothing for you.

STILL MAD HE NEVER CALLED YOU BACK, GAMORA? —STAR-LORD

The Baxter Building: Before Tony Stark's name towered over Manhattan, there was another edifice that served as the symbol of humanity's progress: the Baxter Building. Named for the business that originally occupied it, the Leland Baxter Paper Company, this building gained its notoriety thanks to one—or, rather, four—of its most recognizable tenants, the Super Hero team known as the Fantastic Four. Occupying the upper five floors of the building as their headquarters and research facility, the team made thousands of important discoveries here that helped shape not only the future of humanity,

but often the universe itself. It can be argued that, without the great discoveries and sacrifices made by this team of "imaginauts," reality as we know it would no longer exist. Since the Fantastic Four disbanded, a new tenant has taken up residence on the Baxter Building's upper floors. Parker Industries, a leader in consumer technologies, is proudly carrying on the Richards family legacy of scientific discovery while honoring their history with weekly tours and a stunning statue in the lobby dedicated to the memory of the world's greatest heroes.

The Fantastic Four were truly great heroes. For humans. —Gamora

YEAH . . . HEY! —STAR-LORD

Schaefer Theater: This long-abandoned entertainment venue has recently found new life as the headquarters for some of Earth's mightiest heroes. As the Schaefer's marquis clearly displays, the Avengers are the headliners here, but don't expect to find the cast of star-spanning heroes that you've come to recognize in your corner of the galaxy. This is the home to the all-new Avengers Unity Squad, a team assembled in order to foster cooperation among three unique Earth cultures: humans, mutants, and Inhumans. Though the Avengers' base may be off-limits to the public, the lobby of the theater has been converted into a gift shop honoring one of the team's newest members, Deadpool, who has become extremely popular with humans of late for his gun-toting, wisecracking brand of heroics. *Then they are gonna LOVE me! —Rocket*

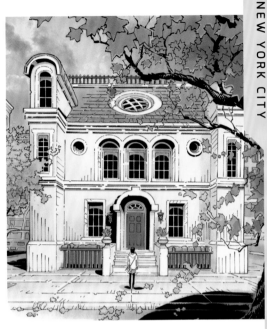

Greenwich Village: A change of pace from the skyscrapers crowding Midtown, Greenwich Village is home to a mix of quaint brownstones, eccentric boutiques, and delicious cuisine. Though the counterculture movement that originally made this district famous may have ended decades ago, the enthusiastic young students of Empire State University have helped to keep the area fresh and vibrant. There's something unique and exciting on every corner—especially on Bleecker Street, where you can find the Sanctum Sanctorum of one of the most powerful magicians in the known universe: the Sorcerer Supreme, Doctor Strange. Knock at your own risk! *"Green-witch"? Thanks, but we've already—*

Write one more word, and you lose a paw.

Hell's Kitchen: Once a run-down neighborhood riddled with crime, Hell's Kitchen has seen somewhat of a renaissance in recent years. This can be attributed to its proximity to the city's tourist-friendly theater district, investments by local entrepreneurs like Wilson Fisk, and an increased presence of crime-fighting heroes such as Daredevil. While new, trendy eateries pop up in this formerly middle-class neighborhood every day, there are still a good number of local businesses and classic watering holes that have allowed Hell's Kitchen to retain its original flavor—and just enough criminal presence to keep tourists on their toes! *THIS SOUNDS LIKE ONE KITCHEN I WOULD BE HONORED TO DINE IN. —DRAX*

The Triskelion: Located near the southern tip of Manhattan, this impressive, newly completed structure was designed to house three unique agencies. The first wing contains New York's Wakandan Embassy, representing the most technologically advanced nation on Earth. The second serves as the base for the ground crew for Alpha Flight, the planet's first line of defense against hostile alien attackers. The third, and perhaps most interesting, houses the Ultimates, a group of scientific explorers dedicated to finding solutions to problems of a cosmic scale. Together, these groups actively work to guard not only Earth, but also the entire galaxy, from harm.

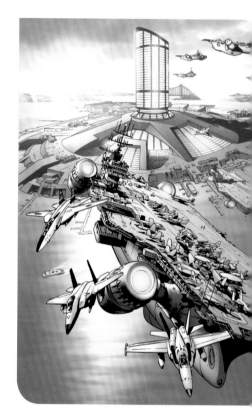

I AM GROOT!
Imitation is the best form of flattery. —Rocket

 ## DINING AND NIGHTLIFE

Whatever your planet of origin, New York offers dining options that will appeal to even the most discerning of palates. On Earth, some chefs have become as famous as Super Heroes, creating elaborate culinary combinations to dazzle your taste buds. Looking for something less expensive? New York is well known for its "pizza," a round disc of thin baked dough covered in crushed fruit and curdled lactose. Also, the city's "shawarma" is a thing of legend, though no local humans were able to tell us exactly what it is.

All these options, but still no place to get a decent plate of Tak'ryll.

The Bar with No Doors: Hidden deep beneath Manhattan, this lounge is open only to magicians skilled enough to find their way inside. If you can convince one of them to grant you entry, you'll find yourself in the company of the most powerful sorcerers, witches, and warlocks in all of existence. With a charming tiki motif and an excellent mai tai (mixed by resident bartender and floating head, Chondu the Mystic), this is one New York hot spot that can truly be considered magical!

I do not believe in magic. —Gamora
Says the girl who once got sparkly cosmic powers from an alien mirror . . .

SHOPPING AND ENTERTAINMENT

In spite of the onslaught of chain restaurants and tacky souvenir stands, New York City still offers some of the best shopping on the planet. Whether you're looking to buy an original Janet van Dyne gown at a Fifth Avenue boutique or a bootleg of a long-forgotten Simon Williams film, this city sells it. Unofficially divided into convenient districts that focus on different wares, New York is the perfect place to find the one special item missing from your collection.

WHICH DISTRICT HAS A COPY OF THE BEST OF ASHFORD & SIMPSON ON CASSETTE? MINE IS GETTING WORN OUT . . . –STAR-LORD

LODGING

New York City has enough hotel rooms to host an entire Chitauri death squadron, but even the least luxurious accommodations can be extremely expensive. Staying in a hotel off the main island and commuting into Manhattan for activities is a much more affordable option. *BUT IF YOU STAY IN JERSEY, BRING A BIOHAZARD SUIT. TRUST ME.*

SERVICES

Misplace your starship on one of New York's countless rooftops? Lose an artifact of immense cosmic power? Suspect your lifemate of secretly spawning with a human? If you've got a mystery to solve, there's one alien eager to lend a wing: Howard the Duck. This refugee from the extradimensional Duckworld has made Earth his home and now serves as one of the city's most available private detectives specializing in cases with otherworldly origins. If you can pay his bill, Howard will help you get to the truth. Eventually. *seriously? what idiot trusts a talking duck?*

I ~~AM~~ GROOT! *I guess I sorta asked for that.*

TIPS FOR A FUN TRIP

DO: Look up! New York City has the largest concentration of Super Heroes on Earth. At any given moment there may be a flaming Inhuman streaking through the skies or a battle with a mutant supervillain taking place on a nearby rooftop.

DO: Make sure you take home a souvenir. They may be cheap and tacky, but there's something admittedly charming about having a tiny snow globe of the NYC skyline displayed on your ship's control console.

DON'T: Look down. The streets of New York are notoriously filthy, and you really don't want to know what you just walked through. *My boots have never been the same.*

DON'T: Actually contain the NYC skyline in a snow globe. The aforementioned Super Heroes will find a way to break out, restore themselves to full size, and return the city to its rightful place, most likely dealing you an embarrassing defeat in the process. *SERIOUSLY. STICK WITH THE $10 REPLICA AND SAVE US THE HASSLE.*

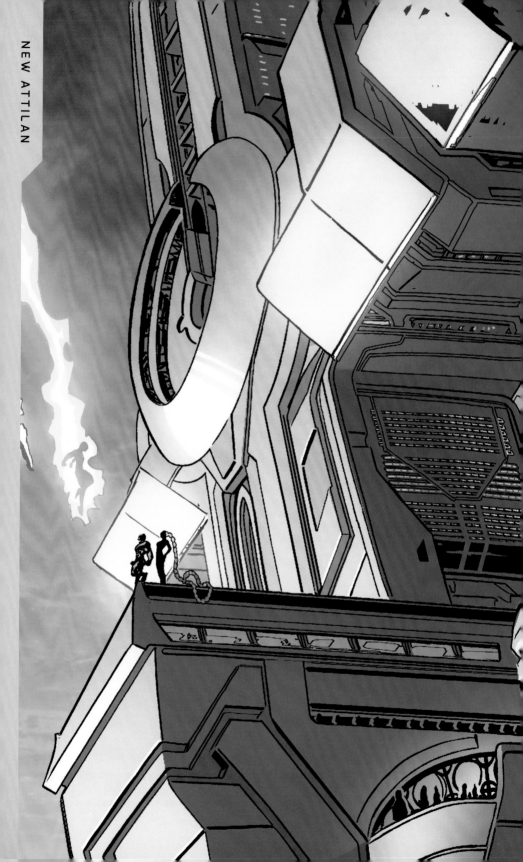

EARTH: NEW ATTILAN

MORE THAN HUMAN

Just beyond the aging spires of Manhattan lies another island teeming with new life. Its alien architecture and superpowered populace may exist side by side with the epicenter of the human world, but they are clearly something altogether different—something Inhuman.

 ## HISTORY AND CULTURE

Millennia ago, the Kree visited Earth to perform a series of experiments on the emerging human race. What they created was a genetic offshoot of humanity that could develop amazing biological powers when exposed to the vapors of the Terrigen Mist. When the experiment was completed, the Kree departed, leaving these Inhumans to forge their own evolutionary path.

SOUNDS JUST LIKE THE KREE. LOVE 'EM AND LEAVE 'EM. —STAR-LORD

Sounds more like you, Quill . . . —Gamora

Over time, the majestic Inhuman capital city, Attilan, became a refuge for members of this unique society, protecting them from a world that feared their powers. Although Attilan was located safely in the Himalayan mountain range, the Inhumans still suffered humanity's persecution and faced too many dangers posed by those beyond their city's walls. Using their highly advanced technology, the Inhumans were able to launch their entire city into space, isolating themselves from their home world in order to save their people. For a time, the city of Attilan rested on the Blue Area of Earth's Moon. It even toured the cosmos as the Inhumans explored their extraterrestrial ancestry.

I remember that tour. Still got the T-shirt. —Rocket

When Attilan finally returned to Earth, hovering directly above New York's Hudson River, the reunion was less than pleasant. During a major conflict with Thanos, the city of Attilan was destroyed. Debris rained down on the river below, some of it causing major damage to nearby New York City. And worse, the volatile Terrigen Mists were released across the globe. Panic ensued as seemingly normal human citizens, unaware of their Inhuman ancestry, were suddenly and unwillingly transformed into superpowered individuals upon exposure to the mists.

Now, the Inhumans are rebuilding their city—dubbed New Attilan—on the ruins of their original capital. They are also rebuilding their society, actively seeking out those citizens whose powers have recently been activated for the first time and welcoming them into their fold. And, most important, they are rebuilding their relations with their human neighbors, trying to convince a frightened world that humanity and Inhumanity aren't really that different after all.

I AM GROOT.

Awww. Aren't we all, pal? —Rocket

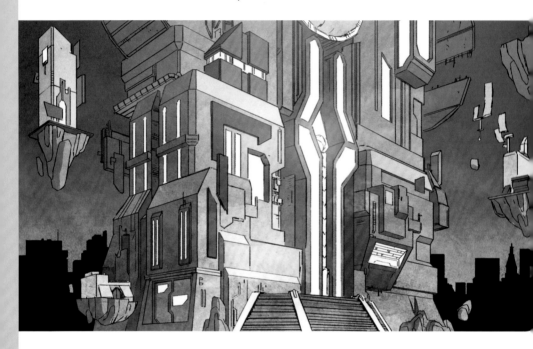

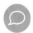 ETIQUETTE

The Inhumans of New Attilan are generally a welcoming people, determined to build bridges between cultures. They encourage visitors from all planets and walks of life. However, Inhumans are fiercely protective of their own, so tread cautiously and be careful not to insult them—especially their royal family. *THEY'RE TALKING TO YOU, ROCKET. –STAR-LORD*

How was I supposed to know she was a princess?!

GETTING AROUND

Many Inhumans are gifted with powers that allow them to travel at great speeds over land, sea, and air, so traditional transportation options on New Attilan are limited. Nontraditional options, however, are abundant— including teleporting dogs and a giant Inhuman head that can instantaneously transport you to wherever it is you need to go!

I think I shall walk. —Gamora

SIGHTS AND ACTIVITIES

Royal Inhuman Vessel (R.I.V.): If you time your visit right, you may get to see the R.I.V.—a diplomatic vessel designed to provide aid to newly emerging Inhumans and the countries affected by the Terrigen Mist. This impressive ship is usually away on important missions, but it occasionally returns to dock at its home base of New Attilan. Tours are available.

I'd like to steal that baby and take it on Rocket's Incredible Voyage!

DINING AND NIGHTLIFE

The Quiet Room: Although this bar is technically located in nearby Manhattan's Grand Central Station, it has such strong ties to the Inhumans that it might as well be part of New Attilan itself. The establishment's proprietor, the former Inhuman king, Black Bolt, uses the Quiet Room as a neutral ground for Inhuman relations with the outside world. If you'd like a well-crafted cocktail and the opportunity to rub elbows with some of Earth's most influential inhabitants, this is the bar for you!

QUIET? A BAR IS FOR REVELRY, NOT SILENCE! I SHALL HAVE WORDS WITH BLACK BOLT! —DRAX *GOOD LUCK WITH THAT . . .*

TIPS FOR A FUN TRIP

DO: Take the time to learn about the complex history of the Inhuman society, including the ritual of Terrigenesis. The New Attilan Royal Library has countless resources on these topics available to all visitors.

DON'T: Go through the Terrigenesis process yourself. Terrigen Mist may give the Inhumans their great powers, but it can cause harm to other species. Most recently, Earth's mutants have found themselves extremely ill from Terrigen exposure, and there's no telling how it might affect alien physiology.

I'd risk it for some sweet wings or laser eyes!

Did You Know?

• The Terrigen cloud that was released during the destruction of Attilan is still circling the globe! If you detect high Terrigen levels during your travels on Earth, return to your ship immediately to avoid exposure.

• Although the Inhumans of Earth are perhaps the most widely recognized, they are not the only species that were experimented on by the Kree millennia ago. Other alien cultures—including the Centaurians, the Kymellians, and the Badoon—all have similar genetically modified populations.

As if the Badoon were not already bad enough.

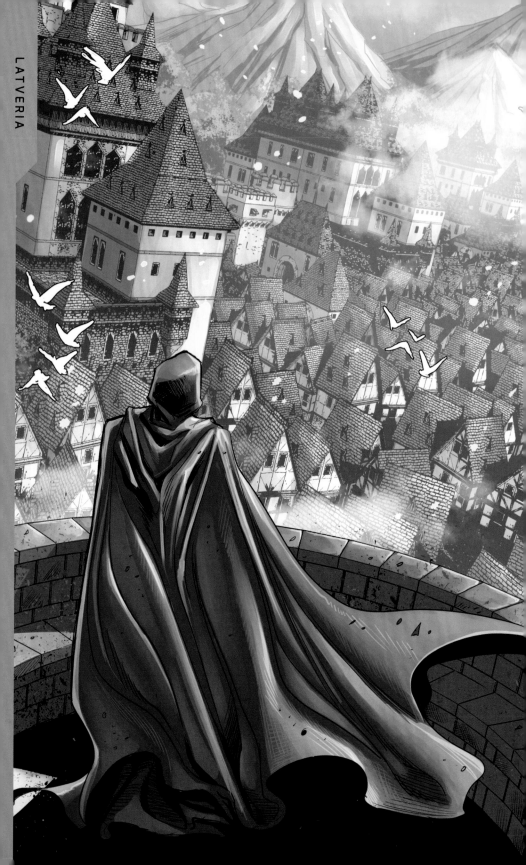

EARTH: LATVERIA

THE NATION OF DOOM

Compared to other technologically advanced locales on Earth, the quaint European nation of Latveria may seem like a step back in time. Don't let Latveria's old-world charm fool you, though, as it was once home to one of the most notorious dictators the universe has ever known—Doctor Doom.

 ## HISTORY AND CULTURE

The "Jewel of the Balkans" was ruled for more than six hundred years by the Haasen bloodline—kings who imposed harsh laws on the nomadic Romany tribes that lived within Latveria's borders. One tribe member—Victor von Doom—saw the Haasen rule lead to the death of both his parents. After studying science and the art of magic, Doom amassed enough power to overthrow the king and take Latveria for himself. *NEVER TRUST THAT MUCH POWER IN THE HANDS OF ONE MAN. -STAR-LORD* Says the former king of an entire planet. —Rocket

Despite Doom's reputation as a cruel dictator, Latveria itself flourished under his rule, achieving economic stability and a decrease in both pollution and crime. The latter, however, is likely attributable to the severity of Doom's penalties for any criminal acts committed within his borders. Streets were regularly patrolled by Doom's robotic enforcers, the Doombots, who managed to keep Latveria's citizens in line via fear and intimidation—a reality in harsh contrast to the idyllic picture painted by Doom's propaganda. I HAD NO IDEA DOOM WAS AN ARTIST. -DRAX

Doom recently absconded from the throne, leaving his nation in a state of political turmoil. Multiple parties are currently vying for control of Latveria, leading to chaos on the streets. Outside visitors should anticipate a more hostile environment than usual until this power vacuum is filled.

Power vacuums are the only kind I like.

That explains the hairballs floating around your bunk. -Gamora

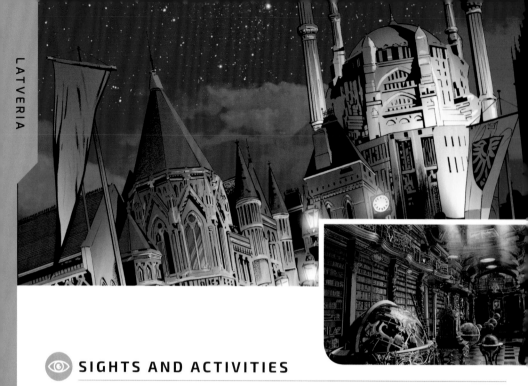

👁 SIGHTS AND ACTIVITIES

Castle Doom: This ancient palace at the heart of Latveria's capital city, Doomstadt, is truly a masterpiece of Gothic architecture. Though the fortress was destroyed countless times during Doom's skirmishes with Earth's heroes, it was always rebuilt soon after, stronger than before. Castle Doom has fallen into disrepair since Doom's departure but is still worth a visit.

> *OKAY, SO WHO ELSE WANTS TO SEARCH FOR ABANDONED ARTIFACTS OF UNKNOWN POWER IN THE CREEPY OLD CASTLE? -STAR-LORD*

Latverian School of Science:

Formerly known as the Latverian Academy of the Sciences, this school was established by Doom to give the brightest minds in his country the chance to study without having to travel abroad. Here, students research and develop cutting-edge technology that can then be applied for the betterment of their nation—or the defeat of its enemies. Visitors are always invited to test the students' latest inventions and take part in clinical trials. Personal safety is not guaranteed.

Latverian Scenic Railroad:

This cross-country tour begins as you board a charming vintage locomotive at Doomstadt Station. As you travel along the Klyne River, you'll pass the majestic Doom Falls before making brief stops in Doomsburg, Doomsdale, Doomsvale, Doomton, and Doomwood. *I am beginning to notice a theme here . . . –Gamora*

 ## TIPS FOR A FUN TRIP

DO: Take home a piece of Latverian culture. Local shops are filled with talented craftsmen who are eager to please by creating a one-of-a-kind keepsake for you.

DON'T: Take home a piece of a Doombot. Even though most of these robotic enforcers have been deactivated in Doom's absence, the technology housed within their shells is still exceptionally dangerous. *NOW THAT IS A SOUVENIR WORTH HAVING! —DRAX*

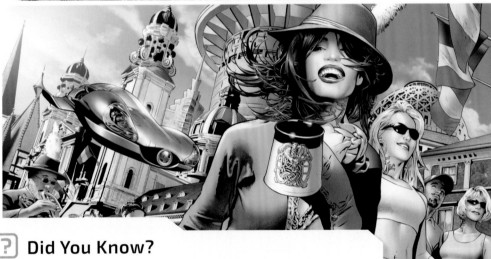

Did You Know?

• Latveria was one of the few surface nations that managed to sign a treaty with the undersea nation of Atlantis.

• Doctor Doom often used special Doombots programmed with his personality as decoys during diplomatic missions. This proved to be a viable security measure, as it was virtually impossible to know which Doom was the real one.

Gotta get me a robot doppelganger. —Rocket

ONE OF YOU IS MORE THAN ENOUGH. -STAR-LORD

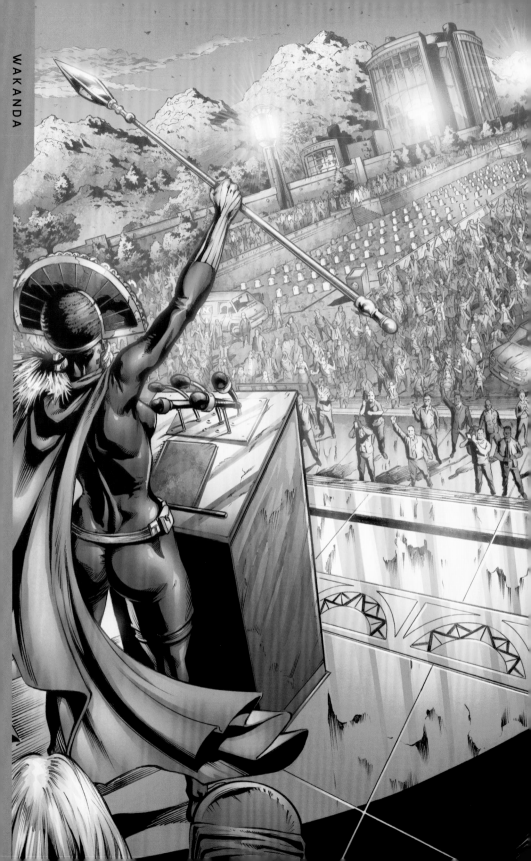

EARTH: WAKANDA

PANTHER'S PRIDE

Located in the heart of Earth's African continent, Wakanda is a nation of many contradictions. Although seemingly primitive in its traditions and government when compared to other Earth cultures, Wakanda possesses and develops technology far beyond the capabilities of more "civilized" nations. Though Wakanda may seem simple on the surface, its people proudly stand on centuries of progress, making this nation the perfect representation of an old Earth adage: "Don't judge a book by its cover."

Unless that book is a Chitauri romance novel. Then, by all means, judge away! —Gamora

I TOLD YOU, THAT WASN'T MINE! –STAR-LORD

 ## HISTORY AND CULTURE

Long ago, a meteor impacted the dense Wakandan jungle, its arrival heralding the beginning of a new age for the nation. The meteor was composed of Vibranium, a rare and extremely valuable ore. By trading small amounts of this precious metal, Wakanda was able to become one of the wealthiest nations on the planet. *If these humans want space rocks, I have plenty to sell! —Rocket*

Wakanda's increased wealth has allowed it to fund the development of groundbreaking technologies not yet available anywhere else on Earth—or many other planets. This combination of technology and wealth has made Wakanda a prize for would-be conquerors. However, that same technology has allowed the Wakandan people to stand strong and repel all invasion attempts. Although the country is isolationist at its core, recent efforts by King T'Challa have begun to open Wakanda's gates to the outside world.

 ## ETIQUETTE

Modern Wakandan culture is actually derived from the traditions of eighteen different tribes, unified under the leadership of the ruling tribe, the Cult of the Panther, and its chief, the Black Panther. It is not expected that visitors be familiar with all tribal customs, but be aware that some sects of the Wakandan populace are less welcoming to outsiders than others. In fact, it is best to avoid members of the White Gorilla Cult altogether.

If only I could avoid the Annoying Raccoon Cult.

what can I say? The people love me!

👕 WHAT TO WEAR

Because of its location near Earth's equator, Wakanda's climate can become extremely warm. Dress in light but protective clothing—especially when venturing into the jungles beyond Central Wakanda.

Or, if you really want to fit in, dress up like a fancy kitty cat.
—Rocket

👁 SIGHTS AND ACTIVITIES

Techno-Organic Jungle: One of Wakanda's greatest creations is a unique hybrid of organic plant life and high-tech Vibranium components, fused together to create a jungle of wires that connect the city and the surrounding areas. This Techno-Organic Jungle acts as the fastest data network on Earth, allowing Wakanda the computing power necessary to run its high-end surveillance and security systems. You'll never find more impressive trees than these!

The Necropolis: This sacred City of the Dead is the ceremonial burial ground for Wakanda's fallen rulers. It is said that the current Black Panther comes to the Necropolis to commune with the spirits of his ancestors. Unfortunately, this stunning collection of ancient tombs and ruins is off-limits to visitors—or at least the living ones. It can be viewed from a distance, however, and is breathtaking to behold.

I AM GROOT! Don't listen to them, buddy.

⇨ TIPS FOR A FUN TRIP

DO: Keep an eye out for Wakanda's most elite soldiers, the Dora Milaje—the "adored ones." These highly trained warrior women lay their lives on the line daily to protect their nation's leader, earning them the title of "deadliest women on the planet." *But not the galaxy. —Gamora*

DON'T: Draw the attention of the Dora Milaje in any way. If they think you pose a threat to Wakanda's ruler, they will not hesitate to break every bone in your body, no questions asked. *I think we will get along quite well.*

? Did You Know?

- The heart-shaped herb that gives the Black Panther his enhanced senses, strength, and agility was originally thought to be a gift from Bast, the panther god. However, scientists later discovered that the herb's transformative properties were actually gained from cosmic energy emitted from the meteor impact site.

- The same cosmic radiation from this Vibranium mound has affected much of the flora and fauna in Wakanda, causing it to mutate, with unusual results. It is best to avoid consuming the flesh of the white gorilla, no matter how rare and delicious it may be.

IT STILL HAS TO BE BETTER THAN WHATEVER ROCKET COOKED US LAST NIGHT. —STAR-LORD

I don't see YOU slaving over a hot stove!

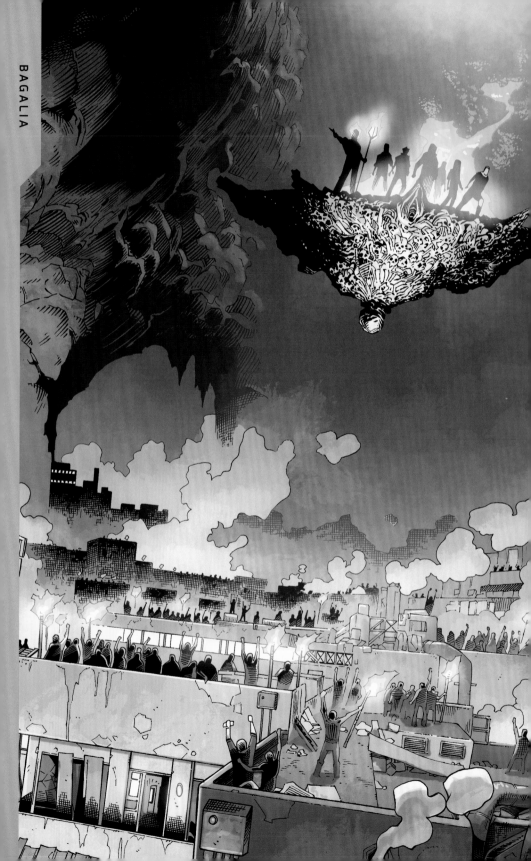

EARTH: BAGALIA

RED LIGHT NATION

If you've noticed a trend by now, it's that Earth seems to be littered with islands of great importance. What makes the nation of Bagalia different is not where it is located but rather who inhabits it. Under the watchful eye of its leaders, Bagalia has become a safe haven for Earth's supervillains, providing sanctuary to the worst criminals on the planet. Because of this, Bagalia is only recommended for travelers with an adventurous spirit—or, perhaps, a death wish.

Sounds like our perfect vacation spot.—Gamora

 ## HISTORY AND CULTURE

A fight between two powerful Earth villains, the Atom Smasher and the Molecule Man, ripped a deep chasm into the island of Bagalia. It was at the bottom of this pit that the nation's secret underground capital, Bagalia City, was constructed, away from the prying eyes of Earth's heroes.

Originally ruled by a mysterious group called the Shadow Council, Bagalia later came under the control of Baron Helmut Zemo, longtime leader of the appropriately titled Masters of Evil. Under his reign, Bagalia has flourished, with superpowered criminals traveling from across the globe to join the community. The spoils from their conquests have fueled the city's growth into the ultimate destination for those seeking a little excitement beyond the confines of the law.

That's the best kind of excitement! —Rocket

I AM GROOT.

Oh, you're no fun.

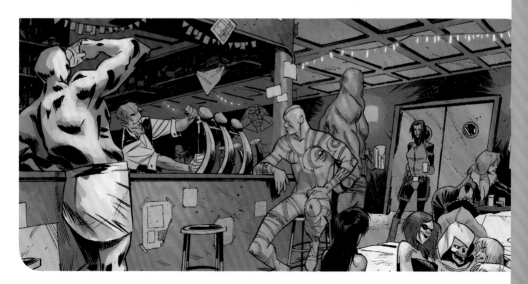

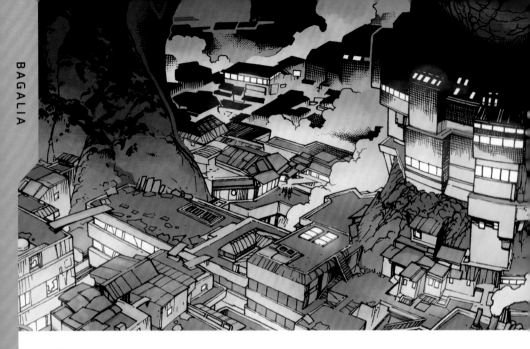

 ## ETIQUETTE

None required. Be prepared to curse at and brawl with virtually everyone you encounter, for no reason whatsoever.

I HAVE FOUND MY NEW HOME. —DRAX

 ## GETTING AROUND

Getting to Bagalia is not easy. In fact, thanks to cloaking technology, mystical enchantments, and data hacking, the island has been all but erased from any existing maps. If you should locate the island, finding your way into the underground city is an equally imposing challenge.

Once inside, though, Bagalia has a surprisingly efficient mass transit system. Since Zemo's rise to power, the monorail has always run on time.

NOTHING HISTORICALLY OMINOUS ABOUT THAT . . . —STAR-LORD

 ## WHAT TO WEAR

Bagalia has no dress code (save for that enforced in some of its high-end gambling institutions), but despite the balmy climate, one should dress with protection in mind. If you have a suit of armor, an alien symbiote, or a werewolf pelt, this would be the place to wear it. The more imposing you look, the less trouble you'll attract!

BUT WHAT IF WE WANT TO ATTRACT TROUBLE?

We manage that quite well as is. —Gamora

SIGHTS AND ACTIVITIES

Tower Zemo: The centerpiece of Bagalia City, the impressive Tower Zemo, houses Bagalia's ruler, as well as his most trusted advisors and enforcers. Its looming presence serves as a constant reminder that Zemo is always watching.

SHOPPING AND ENTERTAINMENT

Bagalia has become Earth's hot spot for black-market goods. If it is stolen, illegal, or insanely powerful, this is the place to buy it. Bring a lot of credits, as prices tend to be as steep as Bagalia City's rocky walls.

MAYBE THEY HAVE THAT ASHFORD & SIMPSON CASSETTE . . .

DINING AND NIGHTLIFE

The Hole: The preferred hangout for Earth's criminal set, the Hole is the perfect place to crack open an expensive bottle of your favorite spirits—before cracking it over someone's head! Even if you make it out of the Hole with only a few bruises, your bar tab is sure to bleed you dry.

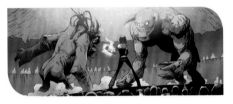

Massacrer Casino: High rollers will want to hit the tables at the most notorious casino in all of Bagalia. A word of caution: The slots may be loose, but security is tight. Try to cheat the house, and you'll pay with your life!

Mephisticuffs: Located in Hell Town, a four-block district of Bagalia devoted to dark magic, this sinister speakeasy turns up the heat each night by hosting a demonic fight club. As you watch the lords of the underworld rip each other into shreds, be sure to try an order of the jalapeño poppers. Sinfully delicious!

How have we not yet been to this paradise?
IT IS AS IF ALL MY TRAVELS HAVE LED ME HERE!

TIPS FOR A FUN TRIP

DO: Get a ringside seat at Mephisticuffs. These demons display tremendous powers during their battles, and feeling the heat of the hellfire up close can be a once-in-a-lifetime experience!

DON'T: Enter the ring, no matter how enticing the prize! Once inside, there are only two ways out: win or die. Unless you'd like to spend the rest of eternity in the belly of a lesser Hell Lord, you're safer on the sidelines.

WE SHALL SEE ABOUT THAT . . .

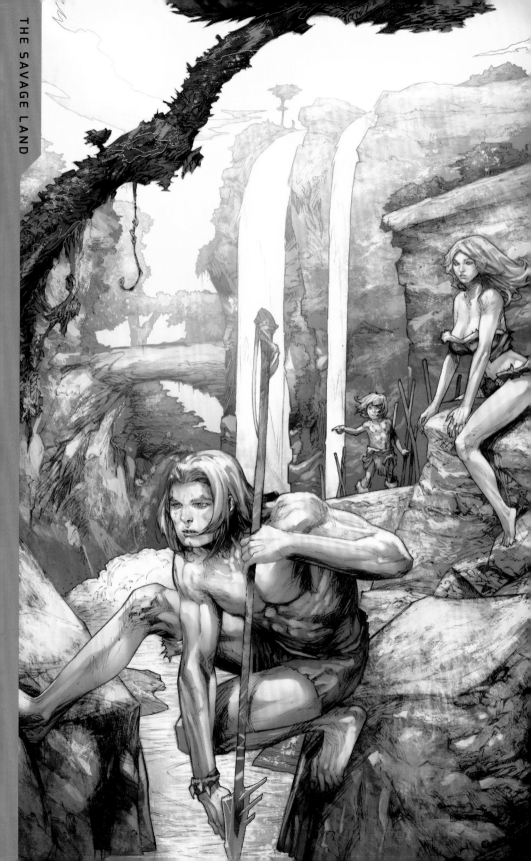

EARTH: THE SAVAGE LAND

LAND THAT TIME FORGOT

Long before humans were the dominant species on Earth, the planet was inhabited by giant lizards called dinosaurs. A cataclysmic event caused these creatures to become extinct millions of years ago—or so it seemed. There is still one place left on the planet where dinosaurs roam freely, a secret valley where human law gives way to the laws of nature—the Savage Land.

 ## HISTORY AND CULTURE

Located near Earth's South Pole on the continent of Antarctica, the secluded Savage Land is unusually tropical when compared to the icy land surrounding it. This can be attributed to the ring of volcanoes surrounding the valley, which were augmented by an alien race over two hundred million years ago to control the local climate and create a region capable of preserving and protecting its plant and animal species—species that have now been designated as prehistoric.

I CAN'T EVEN GET MY SHIP'S A/C TO WORK. —STAR-LORD

Despite a few human and alien visitors over the following millennia, the Savage Land remained relatively untouched until the past century. Thanks to improvements in Earth transportation and exploration equipment, as well as a spike in superheroic activity in the region, this "lost" paradise has been rediscovered and has become a source of intergalactic intrigue. Tourism has increased dramatically, with visitors eager to see these giant prehistoric lizards in their natural habitat.

I saw that movie. It does not end well. —Rocket

BUT THAT LEAD ACTOR IS SOOOOO HANDSOME, RIGHT?

 ## ETIQUETTE

The only law in the Savage Land is survival. Be prepared to fight for your life against any creature that you encounter.

Just another day at the office, then. —Gamora

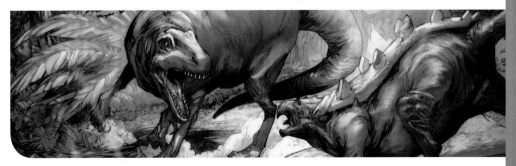

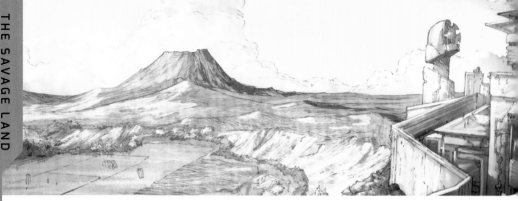

 ## GETTING AROUND

Getting to the Savage Land requires a transport vessel able to withstand the extreme cold of Antarctica. However, the jungles of the Savage Land tend to be too dense for vehicular travel. Be prepared to walk—or run—great distances.

BAH! I SHALL TAME THE GIANT LIZARD BEASTS AND RIDE THEM TO VICTORY!
—DRAX

 ## WHAT TO WEAR

In a place called the Savage Land, it is perfectly acceptable to dress the part. The few inhabitants of the region keep clothing to a minimum. Loincloths are acceptable. Loincloths are NEVER acceptable. —Rocket

? Did You Know?

- The area most commonly identified as the Savage Land—the Prehistoric Refuge—is actually just a small part of this region. Beyond its borders lies an even larger zone named Pangea.

- The Savage Land and Pangea are home to more than just dinosaurs and ancient beasts. The region also serves as the home to several small tribes of humans, as well as dozens of humanoid tribes with unique evolutionary traits, including the Lizard Men, Man-Apes, Cat People, Saurians, Aerians, and Tree People.

 I AM GROOT. MAYBE THEY ARE, TOO, PAL. –STAR-LORD

- Because of the high cost and high danger involved, travel to the Savage Land is still not an option for the average human. In fact, despite plenty of photographic evidence that proves its existence, a large part of Earth's populace still believes that a hidden prehistoric region filled with ancient creatures must certainly be a hoax. Like aliens. I mean, who makes this stuff up?

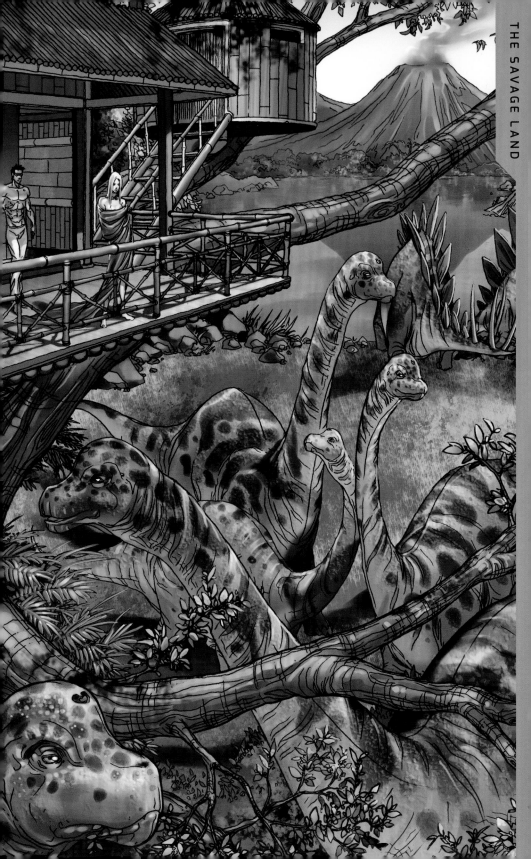

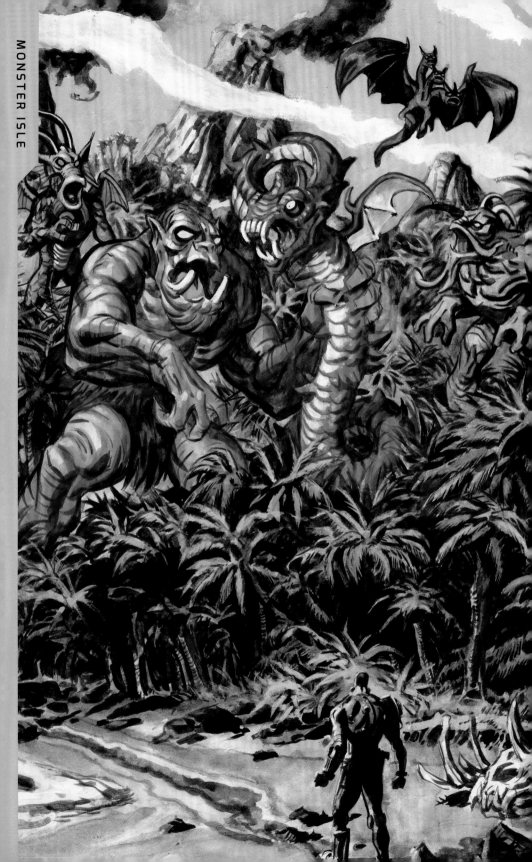

EARTH: MONSTER ISLE

WHERE MONSTERS DWELL

Off the coast of Japan is an island not found on any map. Its origins are unknown, but its inhabitants are some of the most unique creatures to walk the planet—giant beasts, gathered together in a place where they can flourish, completely untouched by humanity.

 ## HISTORY AND CULTURE

Monster Isle had the potential to be one of the planet's most visited tropical tourist traps. Its white sand beaches, temperate climate, and lush vegetation make it a veritable paradise. But, as its name suggests, the creatures that call it home have turned this dream destination into a walking nightmare. Horrific beasts of every variety—winged dragons, giant rock men, sea serpents, and more—have successfully found refuge here, eliminating any chance of human habitation. *Isn't the lack of humans what makes it a paradise? —Gamora*

But Monster Isle is not completely secluded from the world beyond its shore. The island's caves lead to a network of tunnels deep beneath Earth's crust—a hidden empire known as Subterranea. These caverns stretch far beyond the confines of the island, connecting to virtually every continent on Earth. When New York is attacked by a 400-foot rodent, it likely arrived from Monster Isle via Subterranea.

400-FOOT?! WE CAN BARELY HANDLE A 4-FOOT ONE! –STAR-LORD

I am told I'm a handful. —Rocket

 ## SIGHTS AND ACTIVITIES

Elsa's Exotic Expeditions: When the whim strikes her, expert monster hunter and tracker Elsa Bloodstone has been known to lead an exclusive mission to Monster Isle, giving adventure seekers a chance to come face to face with some of the creepiest creatures in all of creation. Although she has never lost a client (as of this publication), there is still a high level of danger involved. All participants are required to pass a six-hour survival course and sign a one-hundred-page liability waiver.

I AM GROOT.

I know. Sounds like she kills more trees than monsters.

🛏 LODGING

Don't come to Monster Isle expecting a four-star hotel with great views of legendary beasts. The island is almost entirely undeveloped. Caves may seem like a safe option, but there's no guessing where they may lead or what may lurk inside. Those visiting may be safest returning to their ships—or perhaps not leaving them at all.

There is one castle . . . —Gamora

WHAT? WHERE? HOW DO YOU KNOW? —STAR-LORD

GAMORA AND I USED TO LIVE THERE. —DRAX

WHAT?! I DIDN'T KNOW THAT!

You know nothing, Peter Quill . . .

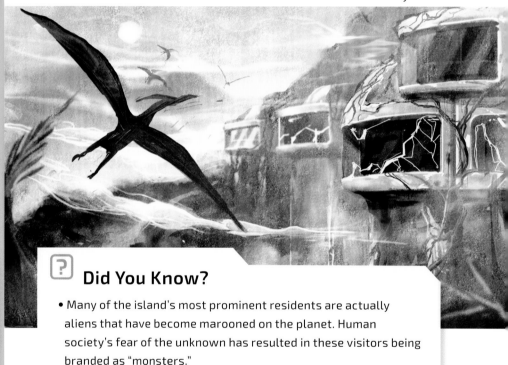

？ Did You Know?

• Many of the island's most prominent residents are actually aliens that have become marooned on the planet. Human society's fear of the unknown has resulted in these visitors being branded as "monsters."

IT'S WHAT WE DO BEST!

• Although most humans avoid Monster Isle, it has occasionally served as the home base for superpowered individuals, including the villain called the Mole Man, as well as popular Earth Super Heroes the Thing and the Hulk.

AND APPARENTLY 40 PERCENT OF MY TEAM.

I AM GROOT.

REALLY? YOU TOO?! SIGH . . .

EARTH: ATLANTIS

THE LOST KINGDOM

Though most of Earth's population evolved to live on the land, approximately two-thirds of the planet's surface is still covered in water. Under the planet's seas exists an ancient civilization of blue-skinned, water-breathing humanoids who call the vast oceans their home: the citizens of Atlantis.

Under the sea, huh? Anything like that cute singing redhead from that movie you showed us, Quill? —Rocket

I WISH . . . –STAR-LORD

 ## HISTORY AND CULTURE

Formerly a small continent on Earth's surface, Atlantis sunk to the bottom of the Atlantic Ocean thousands of years ago during a catastrophic event dubbed the Great Cataclysm. The lost territory lay vacant for centuries before a new species of water-breathing humanoids, *Homo mermanus*, evolved. These new Atlanteans settled the sunken kingdom's ancient structures and restored its glory.

The Atlanteans have long waged war with the surface world, feeling that they have a right to both the land and the sea. This has resulted in the destruction of the undersea nation's capital city on countless occasions, most recently at the hands of Hyperion of the Squadron Supreme. If history has shown anything, it is that Atlantis will rise again.

THAT ARROGANT FOOL NAMOR PROBABLY HAD IT COMING. –DRAX

 ## ETIQUETTE

Atlanteans are not fond of visitors from the surface world (or beyond). It is unlikely that you will be welcomed into their midst unless you can offer them a strategic opportunity to strike at their enemies.

Every strategic opportunity is a chance to strike at your enemies. –Gamora
Which is why no one invites you to parties anymore.

 ## GETTING AROUND

The citizens of Atlantis have developed a strong relationship with the other creatures of the deep, often using them for transportation. Atlanteans have been seen riding whales, turtles, dolphins, giant crabs, and even a number of sea monsters yet to be catalogued by surface dwellers.

For topsiders who are not strong swimmers, it is best to travel via a personal underwater craft with an internal air supply.

FORGET DINOSAURS! I MUST TRAIN A SEA MONSTER TO BE MY STEED!
YOU DO THAT, BUDDY. I'LL BE IN THE SHIP WHERE IT'S SAFE AND DRY.

WHAT TO WEAR

Atlanteans tend to have a minimalist approach to clothing, usually wearing only the most basic garments. It's not uncommon to witness Atlanteans frolicking nearly naked through the surf without a second thought.

> *I'll be glad to give the naked Atlanteans a second thought. And a third. And a fourth. —Rocket*

However, unless your respiratory system was designed to breathe under water and your body can withstand the crushing pressure of the ocean floor, a pressurized diving suit is a must for undersea excursions.

SIGHTS AND ACTIVITIES

Although the capital city of Atlantis has been destroyed, there are still countless colonies spread across the ocean floor. Each one offers its own local customs, unique views of the wonders of the deep, and the freshest seafood anywhere on Earth, including deep-sea delicacies many surface dwellers have never fathomed.

> *WONDER IF THEY HAVE FISH STICKS. HAVEN'T HAD THOSE THINGS SINCE I WAS A KID! –STAR-LORD*

LODGING

A few Atlantean colonies include areas with breathable air, either covered by glass domes or surrounded by magic spells. These areas are used to house visitors—and prisoners—from the surface world.

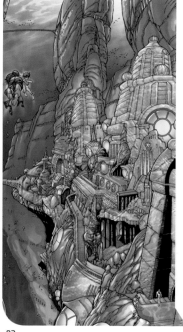

 Did You Know?

- Another undersea civilization exists on the opposite side of Earth, beneath the Pacific Ocean. Populated by a green-skinned offshoot of Atlantean culture, Lemuria is named after another ancient city that sank during the Great Cataclysm. The Lemurians worship Set, an ancient seven-headed serpent god. *Seven heads? That is quite a set!*

- In addition to the blue-skinned Atlanteans and green-skinned Lemurians, a small number of *Homo mermani*—including the late King Namor—were born with pink skin. This rare pigmentation is usually the result of genetic mutation or crossbreeding with humans.

BLUE AREA OF THE MOON

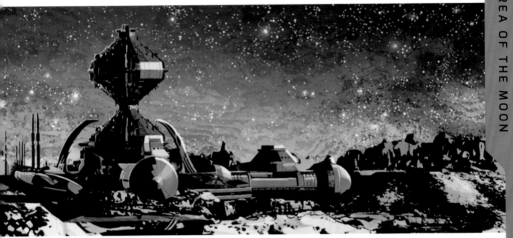

SATELLITE SAFE ZONE

Earth's sole moon seems unspectacular to the naked eye—a large, barren chunk of rock, floating silently in orbit, completely devoid of life. But such was not always the case as there is one area of the moon with atmospheric qualities capable of sustaining life.

THAT'S ONE SMALL BREATH FOR MAN . . .

While this "Blue Area" may be empty now, it has been the site of several important events that have helped to shape the history of the entire known universe.

 ## HISTORY AND CULTURE

Millennia ago, a small faction of primitive Kree were brought to Earth's moon as a part of a test by the then-benevolent Skrull Empire. The Skrull created an artificial atmosphere on the moon and left the Kree for a year to shape their own society however they saw fit. Though the Kree built a stunning city on the moon's surface, the Skrull favored the results of a rival species on another moon. When the Kree returned home to Hala in defeat, they revolted against the Skrull, igniting the centuries-long Kree-Skrull War.

I always thought it started when the Skrull threw the Kree into the harbor . . .

As the Kree and Skrull waged their war across the cosmos, the city on the moon was left to decay, all but forgotten. The breathable atmosphere remained, however, allowing many visitors to make the region their home over the centuries, including the Inhumans—who temporarily relocated their city of Attilan to the moon's surface.

The Blue Area is also known for hosting other events of cosmic significance, including a trial by combat between the Shi'ar Imperial Guard and Earth's X-Men to determine the fate of Jean Grey, the host of the destructive power known as Phoenix Force.

The site long served as the home for another alien of note—Uatu the Watcher—until his gruesome murder.

Some things you cannot unsee. —Gamora

 ## SIGHTS AND ACTIVITIES

Kree Ruins: The Kree may have left thousands of years ago, but what is left of their city is worth exploring. Although space pirates have long since removed all valuable artifacts, the chance to explore early Kree architecture of such great historical significance to the galaxy is still a rare treat. Audio tours are available for download on kreeTunes.

REMIND ME TO CHECK IF THEY'RE AVAILABLE ON TAPE . . . —STAR-LORD

 ## TIPS FOR A FUN TRIP

DO: Bring an emergency oxygen supply. It's easy to wander beyond the artificial atmosphere of the Blue Area without realizing it. Always be prepared.

DON'T: Tamper with anything in the Watcher's home. Although all weapons from Uatu's armory have been secured and relocated since his demise, there may still be plenty of powerful secrets buried in his former residence—secrets with equally powerful safeguards protecting them! There are some things that are best left alone.

Like that weird rash on my back. —Rocket

I AM GROOT.

Well, if you're that worried, book me an appointment!

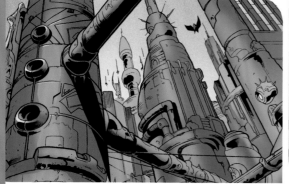

COUNTER-EARTH

UNNATURAL SELECTION

Located in Earth's orbital path on the exact opposite side of its sun is an artificial planet carefully designed to be an exact replica of its celestial partner. On the surface, Counter-Earth may seem to be Earth's perfect twin, but it is the horrific events occurring on its surface that set Counter-Earth apart.

 ## HISTORY AND CULTURE

Counter-Earth was created by the superpowered geneticist known as the High Evolutionary using unknown means. On his original version of Counter-Earth, the High Evolutionary attempted to control the evolution of humanity. That experiment failed, and the planet was eventually destroyed. He has since rebuilt and has shifted his focus to his own race of highly evolved animals called New Men. The High Evolutionary's experiments have granted these New Men heightened intelligence and physical abilities, making them the perfect human-animal hybrids. *I like this place already! Let's go!*

Of course, perfection is in the eye of the beholder—and the High Evolutionary refuses to accept even the slightest flaws in his new society. He carefully selects the New Men that get to live in the planet's capital city, choosing only the specimens who will provide the best chance for genetic superiority. Should these chosen New Men show any sign of imperfection, whether physical, emotional, or social, the High Evolutionary shows no mercy, destroying the capital city and everyone who dwells within it, only to start his grand experiment again in another location.

I changed my mind.

95

After each culling, another artificially created race called the Green Ones—creatures turned into living wood via a plant-based virus—consume the remains of the fallen New Men and return the charred cities to a green state capable of supporting life once again. **I AM GROOT!**

 ## ETIQUETTE

Counter-Earth is not welcoming to outside visitors. The population of New Men in the planet's capital city are bred to believe themselves superior to all other races and look down on "less evolved" cultures. And while the High Evolutionary himself may take interest in your arrival on the planet, it is likely only because he wants to exploit your species' genetic traits for his own future experiments. Visit at your own risk.

Not surprising that the only place less welcoming than Earth is another Earth. —Gamora

 # SIGHTS AND ACTIVITIES

Lowtown: Built from the wreckage of past genocides, this shantytown is the home base for Counter-Earth's primary resistance force. The group of rebels is composed of rejected New Men and survivors of the High Evolutionary's frequent exterminations. These "imperfect" soldiers have banded together to stop the High Evolutionary's cycle of destruction. All are welcome in Lowtown, especially those willing to hold a weapon and join the crusade!

SET THE COURSE FOR LOWTOWN, QUILL! REVOLUTION AWAITS! —DRAX

Ghost Town Temple: Long rumored to be haunted, this majestic temple is one of the few structures still standing in one of Counter-Earth's many decimated capital cities. Even though the souls of the High Evolutionary's fallen children have now moved on, one cannot help but feel the weight of their sacrifice when exploring the chilling silence of these ruins.

 # TIPS FOR A FUN TRIP

DO: Enjoy the diversity. Counter-Earth isn't a zoo, but the New Men are evolved from a wide selection of animals, creating a society filled with a fascinating variety of unique citizens.

DON'T: Show any sign of weakness. On Counter-Earth, only the fittest survive.

GOOD THING I'VE BEEN HITTING THE GYM. —STAR-LORD

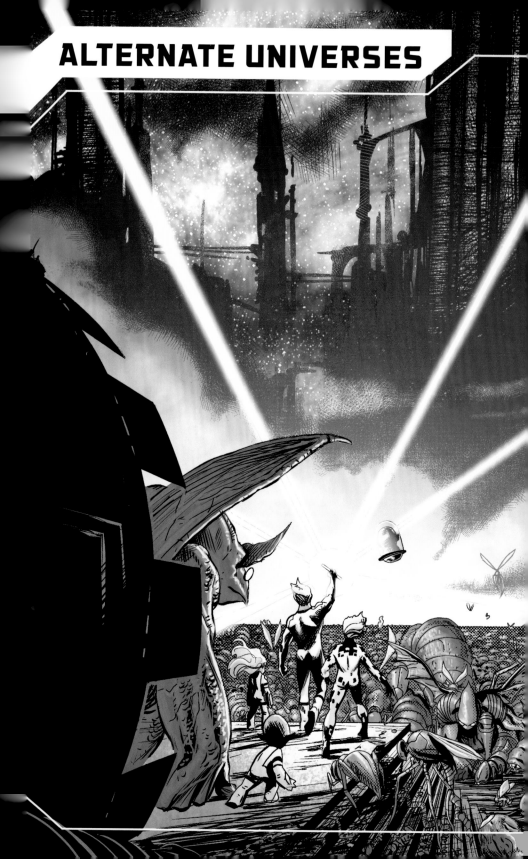

INTO THE BREACH

If you feel like you've been to every tourist destination in the universe and are looking for a fresh and exciting new place to explore, perhaps you're ready to cross over into an alternate universe.

OR YOU COULD JUST BE HAPPY WITH WHAT YOU HAVE FOR ONCE! YEESH! -STAR-LORD

It is theorized that an infinite number of possible universes exist beyond the borders of our own reality. Some of these parallel dimensions contain alternate worlds nearly identical to our own, while others differ so greatly that even our basic laws of physics do not apply there. *Laws rarely apply to us, no matter what dimension we're in. —Rocket*

These are the realms where magic and mystery are born, teeming with ancient creatures and unexplained energies. These universes have occasionally crept across into our own, leaving behind the stuff that dreams—and nightmares—are made of.

Many of these alternate dimensions have strong ties to ours and are easily accessible via forgotten portals, mystical bridges, and rifts in space/time. Other dimensions were sealed off from our reality eons ago for our own safety but can still be explored by courageous travelers willing to pay the right price.

When will people learn that some doors are closed for a reason? —Gamora

Hey, if you're on a ship with only one bathroom, maybe you should learn to use a lock!

While it would take an infinite number of pages to explore all these realities, this volume will focus on a number of omniversal highlights. Each one of these realities was selected based on its overall impact on our own universe—either positive or negative. They may not all make your must-see list, but we guarantee that all of them must be seen to be believed!

IF WE CANNOT BELIEVE IN THE ONES THAT WE DO NOT SEE FOR OURSELVES, THEN WHAT GOOD IS THIS BOOK?! —DRAX

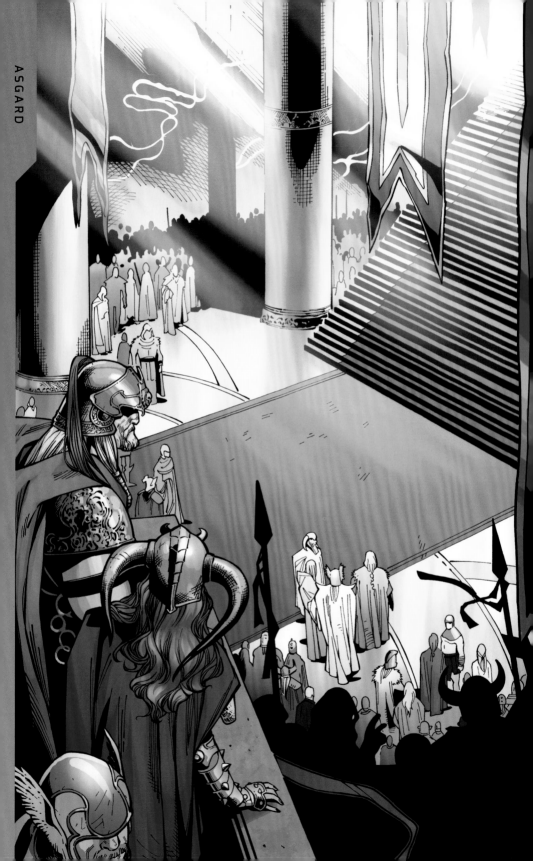

ASGARD

JOURNEY INTO MYSTERY

The Ten Realms of Asgard are a collection of mystical worlds just beyond the veil of our reality. The ancient warriors and fantastic beasts that call Asgard home have inspired countless legends that have echoed across our universe for eons.

YET SOMEHOW THOR ALWAYS ENDS UP TELLING THE EXACT SAME STORY EVERY TIME HE HAS TOO MUCH MEAD. —DRAX

Asgard has always had strong ties to this dimension. In fact, if you've read this far, you've already had an in-depth look at one of Asgard's realms. The Asgardians may call it Midgard, but we know it better as Earth.

So does that make Quill a Midgardian of the Galaxy? —Rocket

I AM GROOT.

Like you weren't thinking it.

So grab your shield and pray to Odin, because the time has come to venture across the majestic Rainbow Bridge to explore the nine other vastly different landscapes that form this fabled kingdom.

Am I the only one who finds the idea of traveling by rainbow unsettling? —Gamora

OTHER THAN THANOS, CUTENESS MAY BE YOUR GREATEST FOE. —STAR-LORD

I'll never forget that puppy on Alpha-Centauri!

Nor will I . . .

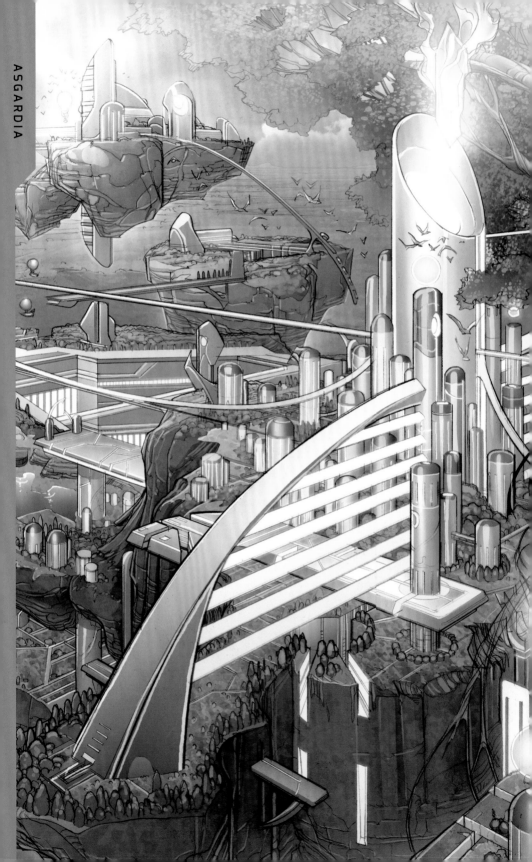

ASGARD: ASGARDIA

REALM OF GODS

Asgardia is the capital of the Ten Realms and home of the Norse gods. These hallowed halls ring eternally with the cries of battle and the cheers of victory. Once you experience the splendor of this fabled Golden City, you'll be cheering, too!

 ## HISTORY AND CULTURE

The Aesir—more commonly known as Asgardians—are powerful beings worshipped by many cultures as gods. For centuries, the Aesir made their home in the extradimensional realm of Asgard, where they built a Golden City of unparalleled beauty as their capital. Odin the All-Father ruled all of Asgard's realms from this throne until Ragnarok—the end of the god cycle—finally arrived. The old Asgard died along with its people.

From death eventually came rebirth, but Thor decided to build the new Asgard on the plane of Midgard (Earth) in hopes of being closer to those that might need the help of the gods. This new Asgard attracted the attention of countless foes, both superhuman and divine, yet was eventually destroyed by the violent acts of mortal men. *Men. It figures. –Gamora*

Undeterred, the Asgardians rebuilt again, this time forging their new city from a union of Asgardian magic and cutting-edge Earth technology. This glorious floating city, dubbed Asgardia, eventually returned to the stars. It now hovers in the space just beyond Earth's moon.

"Cutting-edge Earth technology"? Now there's an oxymoron! —Rocket

I AM GROOT.

Who you callin' a moron?!

 ## ETIQUETTE

Asgardians are a proud and stubborn people, more likely to start a war than admit their own faults. They are used to being worshipped by other cultures and don't like to have their actions questioned by those they view as lesser beings. While many Asgardians have grown more understanding of mortals after spending time on Midgard, there are still some that will pummel you simply for looking at them the wrong way.

SO, BASICALLY, THEY'RE DRAX. –STAR-LORD

Helpful Hint: Nine out of ten times, a barrel of mead is enough to solve any problem.

I DO NOTICE THE RESEMBLANCE . . . –DRAX

 ## GETTING AROUND

If you don't happen to have a chariot pulled by flying goats, the easiest route to Asgard is via Bifrost—the Rainbow Bridge. Glistening with multicolored magic, this mystical portal can grant you instant access to any location in the Ten Realms. The Rainbow Bridge is guarded by the all-seeing warrior Heimdall, and those who travel its pathways do so only with his blessing.

Note to self: Trade ship for flying-goat chariot. —Rocket

 ## WHAT TO WEAR

Asgardians have a deep appreciation for battle armor—the more ornate the better. If you've got a handcrafted helmet you've been saving for a special occasion, now is the time to polish it up and put it on!

GOOD THING I JUST FOUND THAT OLD CODPIECE ON OUR LAST TRIP TO MOORD! –STAR-LORD *Good for whom, exactly? —Gamora*

 ## SIGHTS AND ACTIVITIES

The World Tree: Yggdrasil is an enormous cosmic ash tree that connects the Ten Realms of Asgard. Invisible to the mortal eye, the World Tree's branches and roots are said to sprawl throughout all of creation. A smaller physical manifestation of the World Tree rises above Asgardia and is still a wonder to behold.

I AM GROOT.

No offense, but I think she may be out of your league.

Palace of Asgardia: With its gleaming spires and towering statues, this majestic castle is the centerpiece of Asgardia. The palace is home to Hlidskjalf—the high seat of the All-Father—where Odin uses the Omni-Stones to view all the realms of creation. Tours were available under the reign of Freyja but have been suspended since Odin's return to the throne.

Odin's Vault: Located on the lower levels of the palace is a heavily guarded storehouse for some of the most dangerous weapons ever forged, including the Casket of Ancient Winters, the Warlock's Eye, the Eternal Flame, and the indestructible armor known as the Destroyer.

DRAX IS KNOWN AS THE DESTROYER! HAVE THEY NO ORIGINALITY?– DRAX

PRETTY SURE THEY GOT THERE WAAAY BEFORE YOU, BUDDY.

Congress of Worlds: Outside the palace, beneath a shimmering dome, another group of rulers fight for the rights of Asgard's people. Unlike King Odin, these senators have each been elected by the people of their own realm to provide them with a voice in the royal court. Wars may be fought on the battlefield, but it is here that peace is kept. The dome is open to the public, except when Congress is in session and on all major holidays.

Heimdall's Observatory: When he's not standing guard on the Rainbow Bridge, Heimdall is in Asgardia's tallest tower, scanning for threats to the Ten Realms. On his watch, no prayer goes unheard, and no wicked deed goes unseen.

I AM GROOT?
Oh, man. I hope he doesn't see THAT.

 ## DINING AND NIGHTLIFE

Asgardian Royal Dining Hall: The largest mess hall in the Ten Realms, this is where the gods gather to feast. Whether celebrating triumphs or mourning losses, the revelry in these halls is known to carry on around the clock, often for days at a time. Visitors are welcome, as long as they have grand stories to tell and epic ballads to sing.

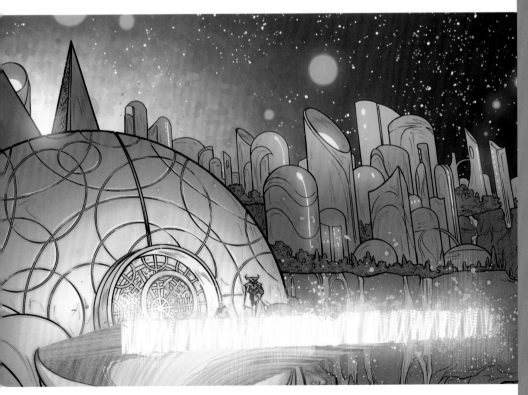

The Lion of Asgard Supper Club: While this is not technically a restaurant, Volstagg the Voluminous occasionally opens his home to his fellow warriors from across the realms for a grand thirty-five-course meal cooked by his wife, Hildegund, and his small army of children. Although the dinners are by invitation only, the host has been known to accept bribes in the form of exotic foodstuffs from the far reaches of the galaxy. *And you guys said I shouldn't have bought all those frozen Acanti steaks... —Rocket*

🛏 LODGING

The city of Asgardia is full of inns and boarding houses, though most rooms are perpetually booked with travelers from across the Ten Realms; reservations can often take a few centuries to open up. If you're willing to help clean the stables, though, one of the proprietors might allow you to bunk down with the horses.

❓ Did You Know?

• Though the city of Asgardia now exists within the boundaries of our dimension, its original home—the extradimensional continent of Asgard—still exists. The spot where the Golden City once stood, however, has been all but abandoned.

• For a time, Odin lived in a self-imposed exile deep within the forests of this Old Asgard, guarding his imprisoned brother, Cul. These siblings have since mended their fractured relationship and have returned to rule Asgardia together.

When last I saw my sister, I left more than our relationship fractured. —Gamora

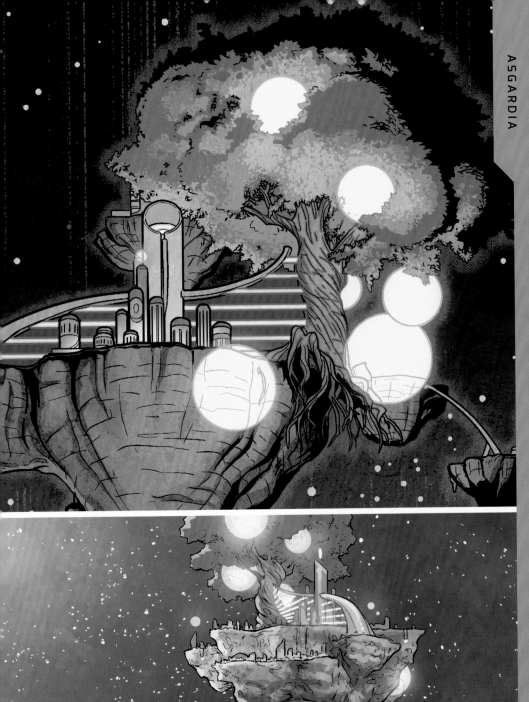
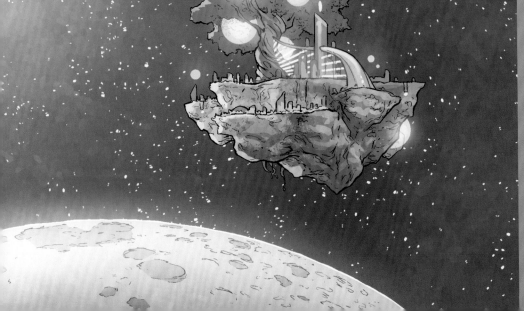

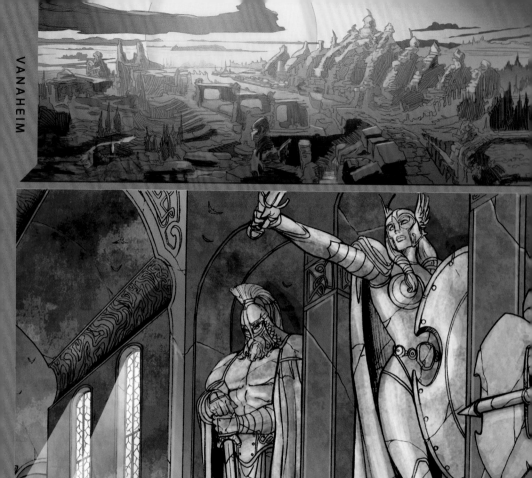

❓ Did You Know?

- Since the unification of Vanaheim and Asgard, it is not uncommon to find the Vanir fighting side by side with their Asgardian allies. In fact, some of the most respected figures in Asgardia—including Heimdall, Sif, Idunn, and Queen Freyja herself—were all born Vanir.

- Even though the Vanir have chosen a more humble existence, they are well aware that there are those in the Ten Realms—and beyond—who pose a threat to all life. They may have put down their swords for now, but should the need arise, they will gladly wield them again to protect those they love.

A true warrior chooses their battles wisely.
Perhaps I would like it here . . . —Gamora

ASGARD: VANAHEIM

REALM OF THE OLD GODS

Just beyond the mountains of Old Asgard sits Vanaheim, land of the forgotten gods. This realm has returned to its roots, celebrating the simplicity of the old ways over the excesses of modern Asgardia. *THERE'S AN OLDER WAY THAN SWORDS AND CHAMBER POTS? —STAR-LORD*

 ## HISTORY AND CULTURE

Vanaheim was once a proud sister-nation to Asgard. Its people—the Vanir— were in every way the equals of their Aesir cousins. These strong warriors built enormous castles and epic monuments that rivaled those of the greatest civilizations in the universe.

The Vanir differed from the Aesir in one important way, though: Asgard seemed to revel in war and would do whatever it took to protect their Golden City. But the gods of Vanaheim saw no point in constant conflict. The Vanir sought wisdom over war, eventually realizing that no castle or statue was worth the loss of their most valuable possession—life.

I felt the same way until I stole my first Oscar. —Rocket

Choosing a life of peace, the Vanir abandoned their great fortresses, returning to the forests. Just as nature has reclaimed their people, it has reclaimed their cities as well, leaving nothing but overgrown ruins where they once stood. **I AM GROOT.**

True. At least the trees have a sweet place to kick it.

 ## SIGHTS AND ACTIVITIES

Temple of Union: Before the Vanir returned to the forests, they fought many great wars against their neighbors. Of these conflicts, none had a greater impact than their war with Asgard. The Aesir/Vanir War raged for centuries but eventually ended with the union of both cultures—signified by the marriage of the Vanir maiden Freyja to Asgard's King Odin at this very temple. Like most of Vanaheim, this ancient structure has been reduced to ruins, yet its great significance in the history of Asgard still stands. To this day, many Vanir-Aesir couples choose this site for their nuptials. For private bookings, send a raven to Wydjung the Planner.

ASGARD: NIDAVELLIR

REALM OF DWARVES

The overwhelming heat and thick, sour air of Nidavellir's underground strongholds is usually enough to deter even the bravest of visitors. But if you've been searching the universe for a unique handcrafted souvenir—or just the perfect blade to vanquish your foes —your quest should begin and end here.

TELL ME MORE . . . –DRAX

 ## HISTORY AND CULTURE

The mist-covered peaks of the Skornheim Mountains may seem like a serene getaway at first glance, but pay close attention and you'll feel a rumbling beneath your feet and hear the faint clanging of hammer and anvil. Directly below these rocky crags, thousands of surly Dwarves are secretly laboring to forge the finest weapons the Ten Realms have ever known.

For centuries, the Dwarves of Nidavellir have provided virtually all of the armaments—from the simplest of swords to Thor's majestic hammer, Mjolnir—that have made the wars on Asgard's surface possible. While war may be good for business, the Dwarves find themselves perpetually annoyed by the petty conflicts between other species.

Aren't we all. –Gamora

 ## ETIQUETTE

The diminutive Dwarves of Nidavellir are an ill-tempered and reclusive species with no time for properness, pleasantries, or personal hygiene. The only things more filthy than their ash-drenched skin are the foul words that regularly spew from their lips.

Short and foul-mouthed?
Honey, I'm home! —Rocket

When in Nidavellir, be prepared to drink heavily and tell lurid tales of your exploits if you want to fit in.

THAT'S ACTUALLY RULE 3 ON THE GUARDIANS' CHARTER. –STAR-LORD

 ## GETTING AROUND

Nidavellir can be accessed via the Pass of Ullthang or the Great Southern Gate of the Sons of Ivaldi. Once you are inside, the realm's endless labyrinth of dark caverns is nearly impossible to navigate without a dwarven guide.

 ## SIGHTS AND ACTIVITIES

The Great Forge: Nidavellir is most famous for its elaborate handcrafted weapons that have been used by the most powerful warriors in Asgard and beyond. Here, beneath the mountain of Ymir-Krul, dwarven forgemasters battle night and day with fiery furnaces, armed only with pickaxes and hammers as they bend molten steel and Uru to their whims. If you are one of the few outsiders granted the rare opportunity to visit, be sure to dress in light clothes and wear ear protection, as both the heat and noise of the Great Forge can be overwhelming.

Nidavellir: If our blinding heat and deafening noise don't kill you, our artisan swords will . . . or your money back! —Rocket

 ## SHOPPING AND ENTERTAINMENT

Leaving Nidavellir without procuring a custom-made weapon is more than a shame; it's a direct insult to the skilled craftsmen who dwell there. Payment may be tricky, however, as the Dwarves do not value traditional forms of currency. In fact, their caverns are filled with more valuable gemstones than they could possibly spend in a lifetime. Dwarves prefer their pay in items of personal value, though some will gladly trade you a sharp blade if you'll teach them a few new curse words from the other side of the galaxy. *DEAL. —DRAX*

 ## LODGING

Dwarves are not known for their hospitality. If your travels should take you to Nidavellir for an extended stay, you'll be expected to live as they do—with virtually no comforts or modern conveniences. Beds are hard stone and are infested with scorpions, pinworms, and ticks. And the natural geysers that provide the only source of clean water are so hot that they are more likely to remove your skin than the dirt that covers it. If all of that isn't already unpleasant enough, you do not want to know what the bucket outside your door is for . . .

Yes I do! Tell me!

I AM . . . GROOT . . .

Oh. Never mind.

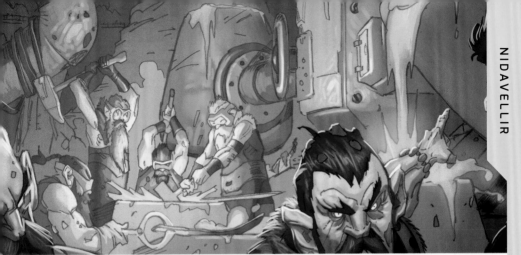

⇨ TIPS FOR A FUN TRIP

DO: Bring your own food. Meals prepared by the Dwarves of Nidavellir are mere moments away from going rancid and taste as though they already have.

DON'T: Bring your own weapons. The Dwarves will mock you mercilessly for their shoddy craftsmanship, and then throw them into the Great Forge to melt them into slag.

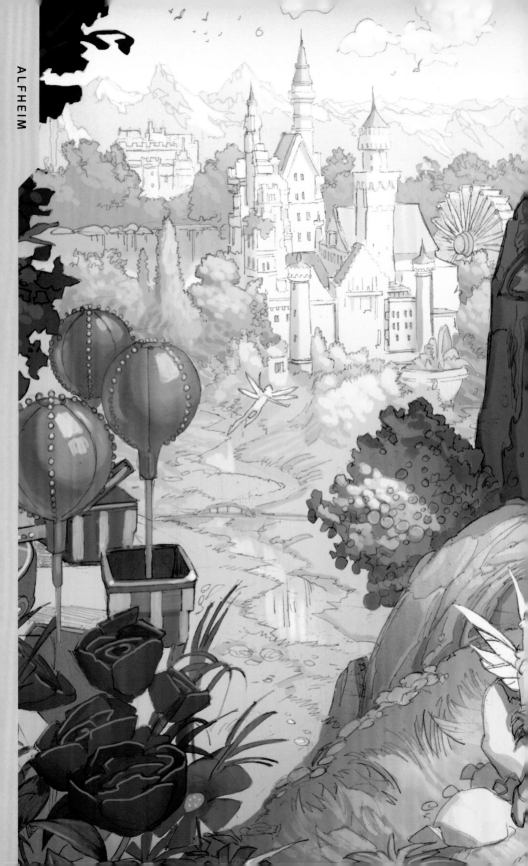

ASGARD: ALFHEIM

REALM OF LIGHT ELVES

The most peaceful of Asgard's realms, Alfheim is a land of endless wonders. With forests full of candy canes and mermaids swimming in natural champagne springs, the land of the Light Elves is every child's dream come true.

 ## HISTORY AND CULTURE

Alfheim is a realm straight from the storybooks. Its endless orchards bloom year-round with Brandywine apple trees and its rolling fields sprout giant gumdrops.

DRAX IS NOT FOND OF SWEETNESS. —DRAX

BEHIND THOSE CONSTANT THREATS OF WAR AND CHAOS, WE ALL KNOW YOU'RE JUST A BIG TEDDY BEAR. —STAR-LORD

The primary residents of this realm are the Light Elves, a race of magical beings with many diverse subspecies including Air Elves, Ice Elves, Moon Elves, Sea Elves, Spice Elves, and more. Though scattered throughout the countryside, the Light Elves are unified under the peaceful rule of Queen Aelsa.

Recently, hundreds of Light Elves were slaughtered when their cousins, the Dark Elves of Svartalfheim, attacked the realm. Alfheim's capital city, Ljosalfgard, is still being rebuilt, but it won't be long before the fields of war once again bloom with rumberries. *Blood does make for a wonderful fertilizer. —Gamora*

REMIND ME TO STAY OUT OF YOUR GARDEN.

 ## ETIQUETTE

Alfheim is all about enjoying yourself. This realm is devoted to joy and pleasure, so nothing is off limits here—unless your Light Elf hosts tell you otherwise. Indulge, but don't try to keep up with the natives. Despite their slender frames, the Light Elves have developed a much higher tolerance to their wines and rums than any other species. *THE DAY AN ELF OUT-DRINKS DRAX IS THE DAY DRAX HANGS UP HIS KNIVES FOR GOOD!*

 ## GETTING AROUND

One could ramble through the fragrant gardens of Alfheim for ages without ever seeing a glimpse of civilization and be perfectly happy about it. But if you're the kind of traveler who wants to get right to the center of the action, the elven capital city of Ljosalfgard can be easily reached via the Queen's Road or the Chardonnay River. Just be sure to stop and smell the ginger blossoms along the way!

 ## SIGHTS AND ACTIVITIES

Honeywine Falls: Follow the Chardonnay River as it forks to the west at Ljosalfgard, and you'll eventually reach Honeywine Falls. As the wine cascades over this wonder, it is naturally aerated, resulting in a pool of bubbly, sparkling deliciousness at its base. If you can still walk in a straight line after your visit, head due south to find one of Alfheim's largest mermaid coves.

I WANNA BE PART OF THEIR WORLD . . . –STAR-LORD

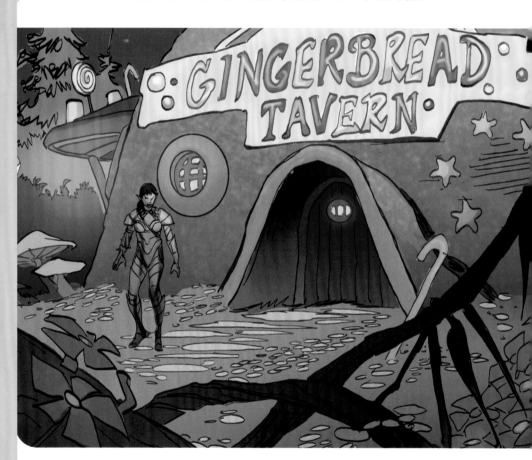

 ## DINING AND NIGHTLIFE

Gingerbread Tavern: Deep in the Sugar Woods in the north of Alfheim sits a house with walls made of pastry. Inside, you'll find something even more delicious—the finest selection of Elf rum and buttergin in the land. The Gingerbread Tavern is welcoming to adventurers from all realms and offers open-air seating and an extensive list of Alfheim's finest wines straight from the Hills of Vin.

I WILL HAVE ONE OF EACH. –DRAX

 TIPS FOR A FUN TRIP

DO: Eat your way through Alfheim. Virtually everything in this realm is edible, from the trees to the homes. Even the faeries themselves twinkle with pure sugar, though it's only polite to ask them before taking a lick. **I AM GROOT.**

See? I warned you. —Rocket

DON'T: Overeat your way through Alfheim. While you may be tempted to fill your belly with free candy, the Light Elves hold the recipes for some of the finest culinary delights in all the realms. Be sure to save some room for dinner!

FEAR NOT. SAVING THE UNIVERSE LEAVES ME WITH QUITE AN APPETITE.

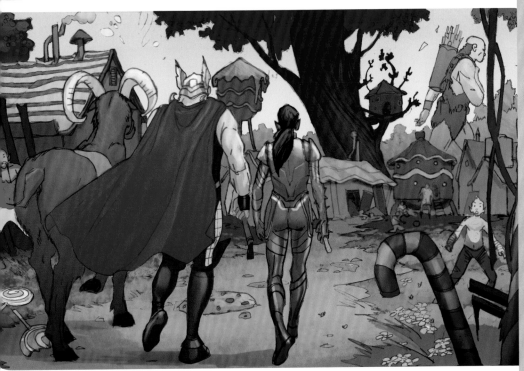

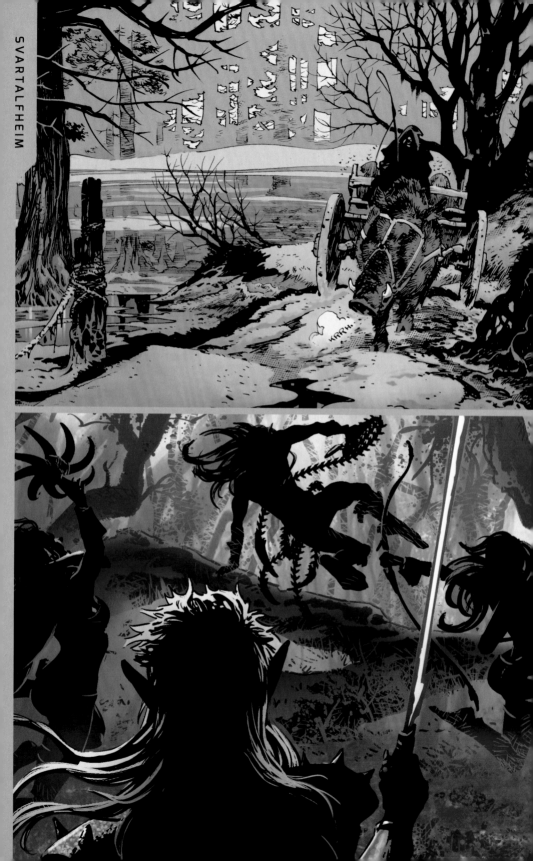

ASGARD: SVARTALFHEIM

REALM OF DARK ELVES

When staying in Alfheim, visitors are encouraged to seek out Elves of every variety to experience their unique regional cultures, traditions, and wares firsthand. But there is one type of Elf in Asgard that no one dares to seek if they value their life—the Dark Elf of Svartalfheim.

 ## HISTORY AND CULTURE

The whimsical delights of Alfheim cannot possibly prepare you for the spine-chilling horrors of Svartalfheim's dark forest. But while the realm's haunted forests, black bogs, and dark caverns may send you running, it is the vile creatures that live in them that should truly cause you fear.

I'M LESS CONCERNED ABOUT SURVIVING THIS PLACE THAN I AM ABOUT SPELLING IT. —DRAX

Unlike their peace-loving Light Elf cousins, most Dark Elves are brutal blue-skinned butchers who dwell in the swamps and practice the dark arts. The Dark Elves can barely stand each other, but their hatred for Asgard's other races binds them together in a common cause.

why does it always gotta be hatred? why can't they be bound together by something nice for once—like pie? —Rocket

The Dark Elves honed their skills of murder and treachery during centuries of unending war against Trolls, Light Elves, and Dwarves. It wasn't until Queen Alflyse took the Ebony Throne that the Dark Elves finally found some semblance of peace with their neighboring realms. But that wouldn't last long.

Peace never does. —Gamora

Svartalfheim recently fell under the rule of a cunning Dark Elf sorcerer named Malekith the Accursed. Since his rise to power, this devious wizard has created chaos, slaughtering his own people, staging attacks against other realms, and building alliances with Asgard's greatest foes.

To advance his treacherous plans, it is said that Malekith used his sinister sorcery to bewitch the Light Elf queen, Aelsa, into becoming his bride. With Alfheim and Svartalfheim united, Malekith has greatly expanded the influence of his Dark Elves . . . and is not likely to stop until all Ten Realms are his to control.

 ETIQUETTE

Outsiders were never welcome in Svartalfheim, but under the reign of Malekith, they are strictly forbidden. If you simply can't resist experiencing the stench of Bloodmuck Swamp in person, be sure not to draw any attention to yourself. If you are discovered, you are likely to become the next target of Malekith's Wild Hunt.

IS IT JUST ME, OR DOES "MALEKITH'S WILD HUNT" SOUND LIKE A SWEET REALITY SHOW? —STAR-LORD

WHAT TO WEAR

Dark Elves are vulnerable to iron, so bring as much of this metal as you can carry in the form of armor and weapons. Also, a good pair of running shoes is recommended.

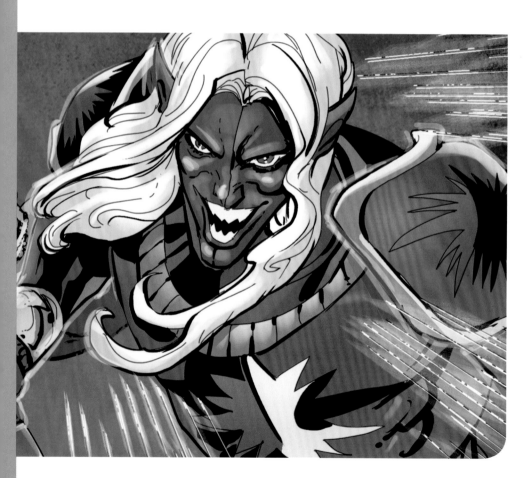

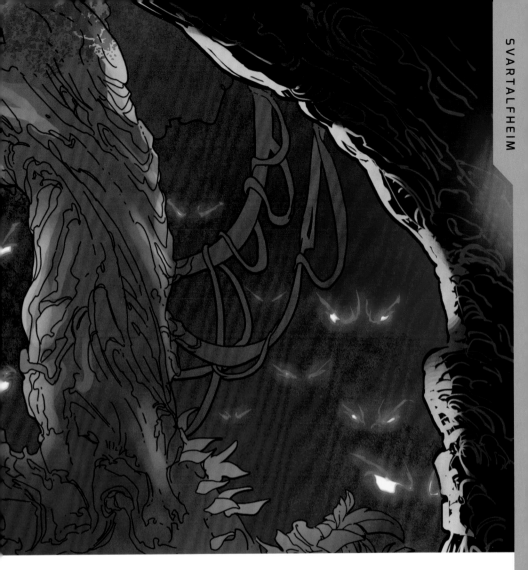

👁 SIGHTS AND ACTIVITIES

Library of Sins: Hidden deep beneath Malekith's lair in the dark forests of Svartalfheim is a vast collection of arcane scrolls containing the most sinister spells ever cast in any realm. From snake hurling to skin flaying, learning a few of these ancient incantations will definitely make you the life—and death—of any party! Library cards are available for free to citizens of the Ten Realms, but the spells themselves may cost you a piece of your soul.

I used to have a library of sins under my mattress. —Rocket

I AM GROOT!

Says the guy with the subscription to Woodland Digest...

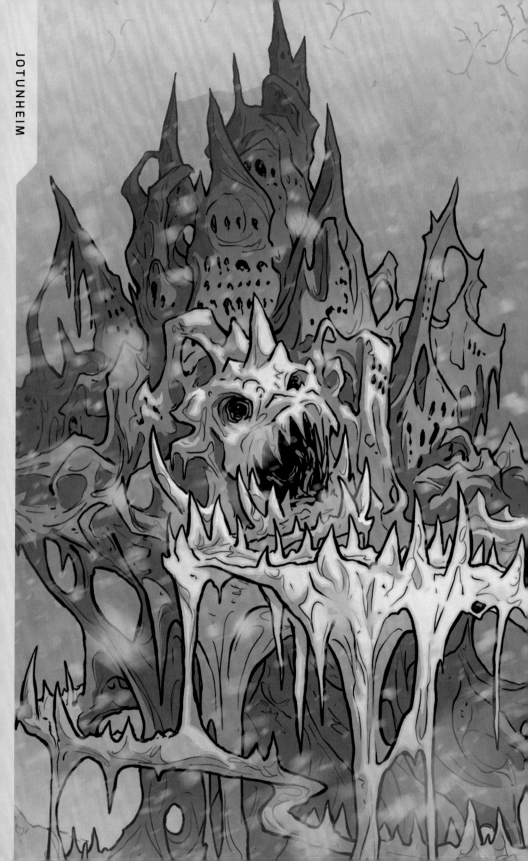

ASGARD: JOTUNHEIM

REALM OF GIANTS

Whether you're traveling south to the Valley of the Storm Giants or to the east into the Mud Alps where the Mountain Giants dwell, there's one thing you're guaranteed to find in every region of Jotunheim—big trouble!

HISTORY AND CULTURE

Jotunheim is the land of enormous humanoid creatures known as giants. Although they are all said to be descended from the first giant, Ymir, each tribe of giants has adapted to the various perils of their home region. But don't expect to have the time to learn the unique cultural differences between Brine Giants, Shadow Giants, Rime Giants, and Lard Giants. You'll be too busy running from them all! *I AM GROOT.* who are you calling a Lard Giant?
I've been working out! —Rocket

Perhaps the most frightening of all the giants are the Frost Giants, who make their home in the Citadel of Utgard in the Snowstone Mountains. These brutal warriors are known for having hearts as cold as the peaks on which they live. Their recently resurrected king, Laufey, is notorious for his hatred of the surrounding realms and all those who reside within them. It undoubtedly won't be long before all of Asgard feels his icy grip once again.

ETIQUETTE

Giants are rude, disgusting creatures who lack civility of any measure. Fighting, cursing, and spitting are not just welcome, they are expected.

I had no idea my teammates were fluent in Giant. —Gamora

GETTING AROUND

Jotunheim's landscape is as wildly varied as its giants. Its muddy valleys and icy peaks only have one thing in common—they are all treacherous. If you must venture through this realm, it is best to keep to the lowlands, preferably along the banks of the Knife River. Traveling into the highlands is not recommended.

BUT I JUST TRADED MY COW FOR THESE MAGIC BEANS. —STAR-LORD

 ## SIGHTS AND ACTIVITIES

Mount Winterfire: To the west of the Snowstone Mountains stands one of Jotunheim's highest peaks. This "snow volcano" is said to erupt molten frost that is cold enough to freeze Ymir himself. None have climbed to its caldera and lived to tell the tale, making this landmark one best viewed from a safe distance.

 ## LODGING

Few dwellings exist in Jotunheim that are built for visitors of normal size. Though some giants may be willing to invite you into their home as a guest, far more of them would prefer to have you as a meal. With such limited lodging options, it is not uncommon for travelers to hide within the walls of a giant's home and feed off the enormous scraps of food that litter their floors.

Honestly, it's not uncommon for me to do that anywhere we go.
—Rocket

Did You Know?

- Jotunheim is home to an extremely rare metallic ore called Eiderdurm. This powerful superconductor remains in a liquid state even at the region's subzero temperatures and can be extracted from the water using electromagnets. Though Asgardian myths may suggest otherwise, scientists have theorized that Eiderdurm may actually be the source of the region's everlasting cold.

 Science. Taking the joy out of everything.
 YOU'RE STILL MAD THAT THE MOON ISN'T MADE OF CHEESE, AREN'T YOU? -STAR-LORD

- The Frost Giants of Jotunheim celebrate only one holiday, to commemorate the arrival of the Mother Storm—a blizzard as big as a galaxy that covers their domain with life-giving ice. During the festivities, the giants hurl their children into the icy storm. Those that return are honored as warriors. Those who do not return were apparently unworthy of being Frost Giants anyway.

 Thanksgiving with Thanos was eerily similar. —Gamora

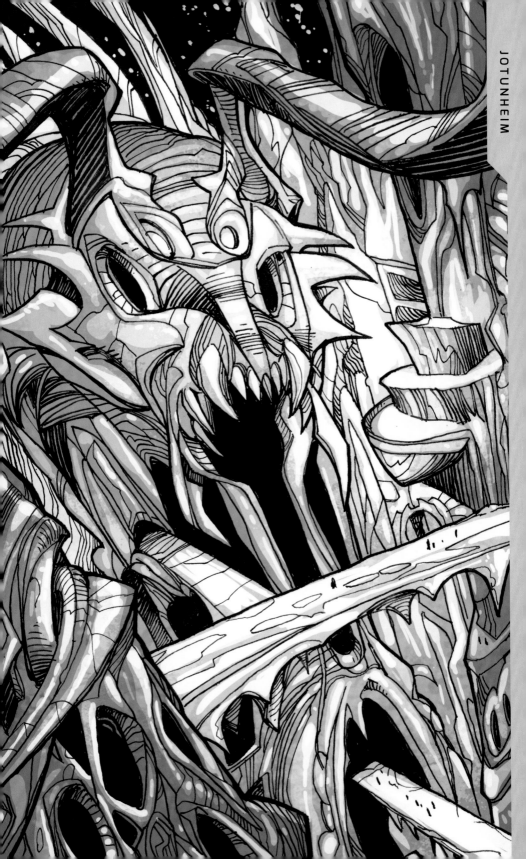

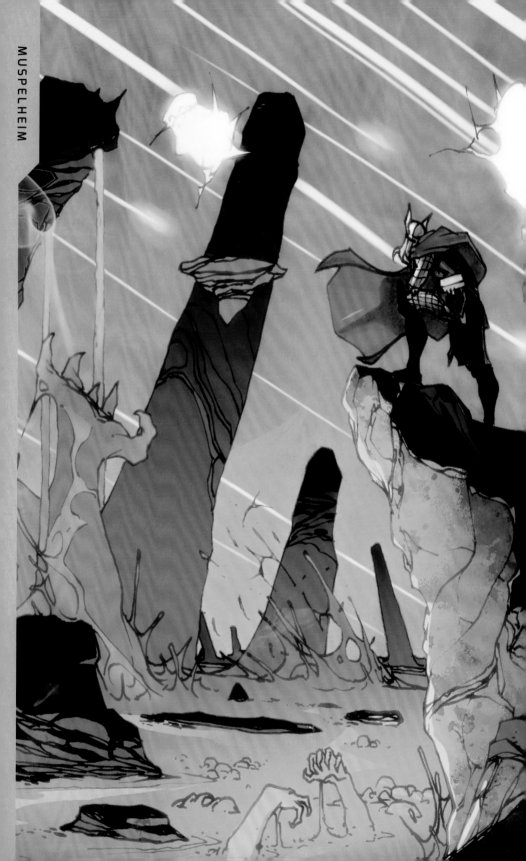

ASGARD: MUSPELHEIM

REALM OF DEMONS

Situated along the southern edge of the Yawning Void known as the Ginnungagap is Muspelheim, land of eternal flame. If your tour of Asgard has brought you here, you are in desperate need of a new travel agent.

I PROMISED BERNICE ONE MORE CHANCE AFTER THAT HOTEL MIX-UP ON GALADOR . . . —STAR-LORD

 ## HISTORY AND CULTURE

Muspelheim is one of the first realms of Asgard. Legends say that the intense heat from this plane mixed with the frigid cold from Niffleheim to produce the other realms. Sadly, that life-giving heat is virtually the only welcome thing that this scorched wasteland has ever offered Asgard. Muspelheim's sweltering terrain spews fire and death from every crack. Its only inhabitants are flesh-eating Fire Demons. The overwhelming stench of sulfur chokes the very breath from your lungs. Travel here at your own risk.

THAT IS THE ONLY WAY DRAX TRAVELS. —DRAX

 ## WHAT TO WEAR

Sunscreen is necessary because of the intense light and heat of Muspelheim's flames. However, you might be better off slathering yourself with a nice marinade, since you are certain to be devoured by demons anyway.

I would taste good with some honey, garlic, and a bit of hickory smoke. —Rocket

I ~~AM GROOT?~~

well, you're not hickory, but I guess you'll do.

[?] Did You Know?

• Virtually every Asgardian prophecy connected to Muspelheim links it to Ragnarok, the end of days.

• Muspelheim was once ruled by Surtur, an enormous Fire Demon wielding a legendary sword that could set entire worlds ablaze. The realm is now under the control of the mysterious Queen of Cinders.

• Two Fire Demons serve as senators in Asgardia's Congress of Worlds, though they seem more interested in burning the Ten Realms than governing them.

And this differs from other senators how, exactly? —Gamora

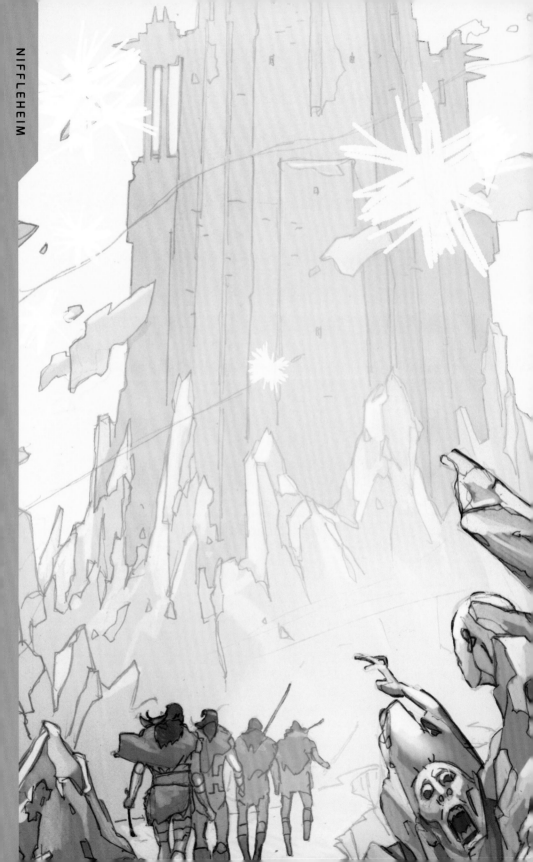

ASGARD: NIFFLEHEIM

REALM OF THE DEAD

Those who live in the icy mists of Niffleheim do not feel the realm's unforgiving chill. In fact, they no longer feel anything at all—because Niffleheim is home to the souls of Asgard's dead.

 ## HISTORY AND CULTURE

This vast continent on the northern edge of the Ginnungagap is split into two distinct regions—Niffleheim and Hel. Both ruled by one queen, they are home to two distinctly different types of souls.

MOTOWN AND MEMPHIS? —STAR-LORD

Niffleheim is the home of the dishonored dead, including murderers, cheaters, and thieves. Their souls are tortured here for all time in a frozen wasteland that makes Jotunheim look like a beach resort. Niffleheim's dreaded "shore of corpses," Nastrond, is home of Nidhogg—a giant dragon who feasts on the dead and gnaws on the roots of the World Tree.

Hel, on the other hand, is not a place of eternal pain and suffering. It is simply the final home for all those who led normal lives and die normal deaths. The giant wolf Garm guards the gates of Hel, making sure that no souls enter or exit without permission of the queen.

NORMAL LIVES AND NORMAL DEATHS. HOW ADORABLY INSIGNIFICANT! —DRAX

The source of Niffleheim's blistering cold is the Well of Hvergelmir, a legendary spring that spawned Ymir and led to the creation of the Ten Realms themselves.

 ## GETTING AROUND

Niffleheim and Hel are accessible via a number of portals and bridges located throughout the Ten Realms. They can also be accessed by those well versed in Asgardian magic. Of course, there is a much easier way to go straight to Hel . . . but it is unfortunately a one-way trip.

I AM GROOT.

Yeah, I think we got what they meant. —Rocket

 ## SIGHTS AND ACTIVITIES

Castle Hela: At the center of Hel stands a majestic tower housing the throne room of the Queen of Hel. From here, she rules the wandering spirits in her domain and ensures the punishment of those who have earned it. Though the throne was long occupied by the goddess Hela, her reign has been overthrown by Angela, a warrior born of Asgard and raised in Heven.

That's my girl! —Gamora

Hall of Nastrond: Arguably the most unwelcoming location in the Ten Realms, this impenetrable fortress serves as a prison to Asgard's most sinister souls. Guarded by gigantic spiders and venomous Hel-snakes, this is a place of eternal damnation that none should enter of their own free will.

I'VE BROKEN OUT OF WORSE. —DRAX

Cave of Aerndis: Hey, ladies! Want to bring home something truly unique to help you remember your visit to Hel? Beyond the River Fimbulthul and the Well of Hvergelmir is a cave that contains an ancient spirit with an ancient secret. Those who perform an arcane ritual here can summon the soul of Aerndis the Teacher, who will share the Berserker Incantation with only the worthiest of warrior women. This spell is said to increase a warrior's strength, skill, and ferocity but may cost them their sanity.

Seems like a small price to pay.

DINING AND ENTERTAINMENT

For a place where souls are sent to spend all of eternity, there is a surprising lack of things to do in Hel. Those who dwell here no longer need to eat or sleep, so the complete absence of restaurants and hotels is understandable. But without any taverns, arenas, or theaters to provide distraction, the afterlife doesn't have nearly as much to offer as one would expect. Don't plan to spend more than a few days here, unless wandering aimlessly alongside the restless hordes who call this realm home sounds like your idea of a good time.

Bet we could make a grutakin' fortune smuggling in iPods! —Rocket

 TIPS FOR A FUN TRIP

DO: Visit old friends. A trip to Hel is the perfect way to reconnect with those you've lost (if those you lost happen to be dead Asgardians).

DON'T: Die. Even in the Realm of the Dead, the living can be wounded and killed. Provoke the wrong spirit, and your quick visit can easily turn into a permanent stay.

Oddly enough, "Don't die" is Rocket's Travel Tip #1.

? Did You Know?

- Niffleheim and Hel are not the only resting places for Asgard's dead. Those noble warriors who fall in battle are ferried to Valhalla—a region of Old Asgard magically protected from the influence of the living. Here, these heroic souls are rewarded with an eternity of endless feasting and fighting.

THE GREATEST VICTORY OF ALL! –DRAX
OTHER THAN, YOU KNOW, NOT DYING. –STAR-LORD
Hey! You read my tips! —Rocket

ASGARD: HEVEN

THE TENTH REALM

The Tenth Realm, Heven, was only recently rediscovered after countless centuries in exile. This forgotten floating city is home to a race of winged warriors eager to reclaim their place in the universe.

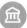 ## HISTORY AND CULTURE

When Earth was still young, its people were under the protection of Angels. With majestic wings and mighty swords, these flying female fighters were paid by the All-Father himself to keep the nascent human population safe from over-zealous Asgardians.

HUMANS ARE NOTORIOUSLY EASY TO BREAK. —DRAX

Preferring riches to honor, the Angels eventually decided that their deal with Odin was no longer good enough. When Odin refused to renegotiate, a war between the realms erupted. At the climax of the war, the Queen of Angels seemingly murdered Odin's infant daughter, Aldrif. As revenge, Odin severed Heven's ties to the World Tree and banished the realm outside all existence.

I AM GROOT.

Hey, even you need to trim back the dead wood sometimes. —Rocket

Heven remained in isolation for eons, but the curse was finally broken when Loki and Thor crossed through the Flux—the gateway between Heven and our reality—in search of their missing sister. As they suspected, she had secretly survived the queen's attack and was raised to be one of Heven's greatest weapons against Asgard—the assassin known as Angela.

A true warrior and friend, no matter where she calls home. —Gamora

With the Flux reopened, a tenuous peace currently exists between Asgard and Heven, but there is no telling how long that will last.

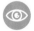 ## ETIQUETTE

In Heven, the philosophy is simple: "Nothing for nothing." No matter what you may have heard about Angels, don't expect these winged warrior women to do anything out of kindness. Here, everything comes at a price—more often than not, one far steeper than you should be willing to pay.

So what're we talkin'? 15 credits? 20?

GETTING AROUND

The city of Heven was designed for a race of beings with wings, so unless you have a pair, it won't be easy to access many of the city's most interesting locales. If possible, bring a jetpack or similar self-propulsion system to get the most out of your visit.

WHAT TO WEAR

The Angels of Heven are very comfortable with their bodies, usually wearing minimal armor. Female visitors should feel free to wear as much or as little as they choose. Male visitors, however, are advised to cover themselves completely to avoid drawing attention.

THAT'S KINDA SEXIST. –STAR-LORD

Now you know how I feel on literally every other planet in all of existence. –Gamora

SIGHTS AND ACTIVITIES

Under-City of the Anchorites: In Heven, it is estimated that only one male is born for every one hundred females. Because of their rarity, males are locked away in temples beneath the city to be guarded as precious commodities. These so-called Anchorites spend their days praying for the lost souls of those Angels who have fallen in battle. Prayer services are open to the public Monday, Wednesday, and Friday.

ONE TO ONE HUNDRED? I LIKE THOSE ODDS . . .

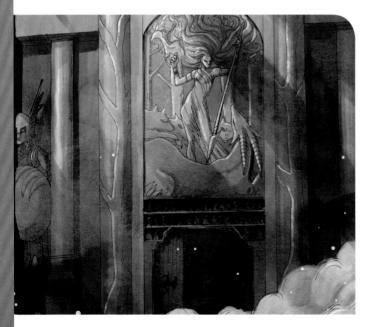

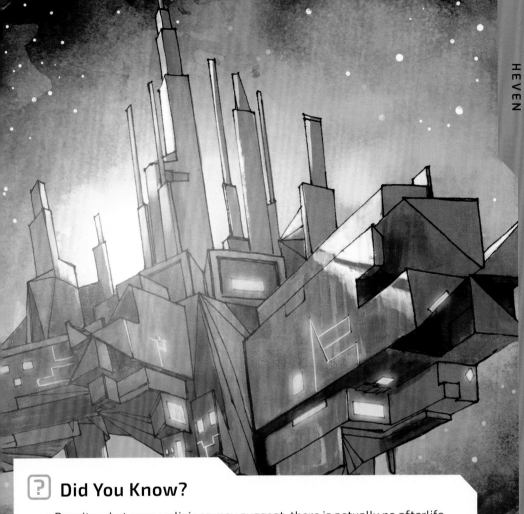

⟨?⟩ Did You Know?

- Despite what many religions may suggest, there is actually no afterlife for the Angels of Heven. Unlike the other Asgardians, their souls are not relocated to Hel when they die. They simply cease to exist.

- Heven is the most technologically advanced of the Asgardian realms. While their warriors still carry swords and shields, they are also skilled pilots who fly an armada of high-tech warships called Dreadnaughts. Their most powerful ships, Destroyers, are said to be able to decimate planets.

 EVEN MORE DESTROYERS?! GAH! —DRAX

- The entire realm of Heven is powered by an enormous engine. After the war with Asgard, the power of Odin's curse was enough to keep the engine running for eons. When the curse was broken, a new source of energy was acquired—the essence of the demon Surtur.

That was when Angela threw that demon baby into the giant furnace, right? Good times. Good. Times. —Rocket

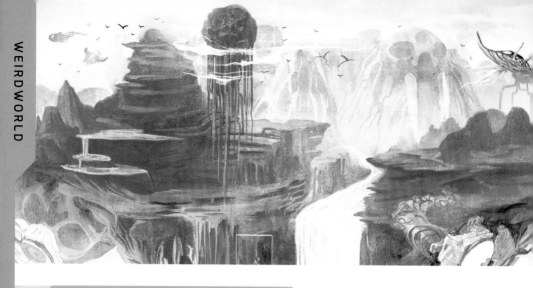

WEIRDWORLD

WHERE LOST THINGS GO

There's an old saying in Weirdworld, that if you tilt the universe on its side, whatever falls out ends up here. A bizarre collection of lost artifacts and forgotten cultures all piled onto a landscape so surreal that it cannot be accurately described, Weirdworld has truly earned its name.

 ## HISTORY AND CULTURE

Few know how to get to Weirdworld, a fantastical realm of myths and magic just beyond the edge of our dimension. Those who do manage to find it are even less certain how to get back home.

Sounds like when we let Drax drive. —Rocket

Once stranded in this domain, inhabitants are forced to face danger at every turn. Mutated plants, lakes of scorching lava, and burning rain are just a few of the natural obstacles visitors will have to conquer. If that's not enough, Weirdworld is also inhabited by a seemingly endless variety of fantastical creatures, such as manphibians, eyemazons, squidsharks, rhinosaurs, and hawksquatches.

IT'S LIKE DR. SEUSS MEETS DOCTOR STRANGE! –STAR-LORD

Weirdworld is home to a number of tribes, from Crystal Warriors and Magma Men to Water-Apes and Flying Pirates. There are even some humans who have found their way to this domain, though most of them are eager to find a way back home. *Typical humans, running from a challenge. –Gamora*

Sorceress Morgan Le Fay considers herself the ruler of Weirdworld, though the many tribes warring against her would be quick to disagree.

 ## ETIQUETTE

Grab a sword. Everyone on Weirdworld fends for themselves, and if that means having to cleave your way through a horde of inbred ogres, so be it!

WE MUST FIND THIS PLACE AT ONCE! —DRAX

 ## GETTING AROUND

Every step you take in Weirdworld is one step closer to death. If the native tribes and wild beasts don't finish you off, the countless perils scattered across the land itself will. Your best option is to view the landscape from above, either in a ship or on the back of a dragon. Tamed dragons can be rented for day trips near the entrance to the Crypt of the Man Maggots.

 ## LODGING

New Avalon Inn: Formerly the Zaltin Inn, this quaint bed-and-breakfast changed its name when Lord Dane Whitman seized control of the nearby castle. Offering stunning views of the Fang Mountains, protection from the Black Knight's army, and a delicious selection of fresh-baked pastries, this is your safest bet when staying in Weirdworld.

who can resist a nice flaky croissant right before getting disemboweled by Demon Dogs?

 ## DINING AND NIGHTLIFE

The Swayin' Saloon: Suspended high above the Forest of the Man-Things is one of Weirdworld's most popular watering holes, the Swayin' Saloon. Here, you know you've had too much to drink when it feels like the room is standing still! Half-price grog on Wizards' Night every Wednesday.

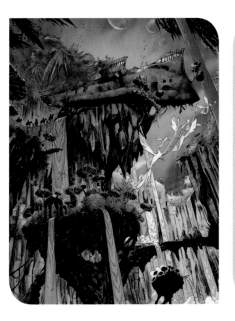

 ## TIPS FOR A FUN TRIP

DO: Get lost in the wonder. There is literally no place quite like Weirdworld anywhere else in existence. If you have a moment to stop running for your life, try to take in as many of the breathtaking sights as you can.

DON'T: Get lost in the Crystal Labyrinth. Even the most skilled adventurers have found themselves trapped within this endless maze for months at a time.

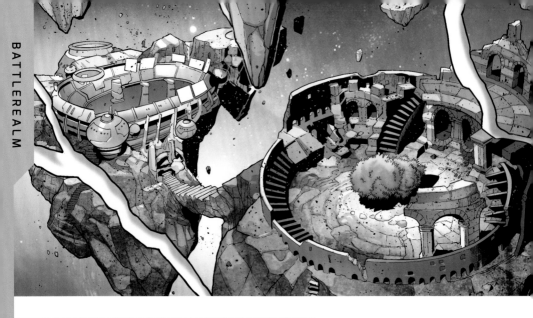

BATTLEREALM

WHERE CHAMPIONS ARE BORN

What do you get when heroes and villains from across all of reality are brought together in a no-holds-barred death match? You get one of the most entertaining blood sports in all of creation. And the best seat in the house is on the chunk of rock where it began—the Battlerealm!

 ## HISTORY AND CULTURE

Legends say that before this universe was created, there existed only Battleworld. This patchwork planet at the end of all existence was created from the chunks of other destroyed universes and is held together by the will of its all-powerful god, Doom. But when the citizens of Battleworld revolted against God-Doom, the planet was destroyed and a new universe—our universe—was born from its ashes.

> *THAT SOUNDS COMPLETELY CRAZY. WHY DO I FEEL LIKE I REMEMBER IT? –STAR-LORD*

One tiny chunk of Battleworld still remains, however, just beyond the edges of reality. The Battlerealm is a place where time and space have no meaning. Here, Elders of the Universe gather to play deadly games for universal power.

> *I prefer playing Chutes and Ladders for a couple of cold Grozznian ales. But that's just me. —Rocket*

 ## ETIQUETTE

Fight. Win. Fight again.

> *ODDLY, THIS IS MY EXACT SCHEDULE FOR TUESDAY. –DRAX*

GETTING AROUND

Battlerealm is outfitted with powerful teleportation devices that can summon contestants from any known reality and any period of time.

LODGING

While staying on Battlerealm, guests are kept inside stasis crystals that dampen the effects of time. The results are quite rejuvenating.

SHOPPING AND ENTERTAINMENT

Contest of Champions: The Battlerealm is home of one of the most exclusive tournaments in all of reality—the Contest of Champions. To compete in the Contest, each player must gather a team of five main contestants to fight. These contestants are forced to compete on the deadliest battlefields plucked from all of creation—from the Savage Land to Svartalfheim. When all five main contestants on one team are defeated or killed, the player who selected them loses the contest. To the winner goes unlimited power on a cosmic scale!

But what happens if my Paladin rolls a nineteen?

? Did You Know?

• Players in the Contest of Champions are rumored to be competing for a source of godlike power known as Iso-8. This crystalline element, also known as Neutronium, is said to be a force of pure creation energy that was forged from the shards of previous realities during the birth of our own world.

• As long as one of the main contestants remains alive, their player can enhance his roster with ringers—powerful heroes that can be swapped in and out of the tournament on occasions when their special skills are required.

• When a ringer is no longer needed in the contest, they are sent back to their home reality, and their memory is wiped.

This seems . . . hauntingly familiar. —Gamora

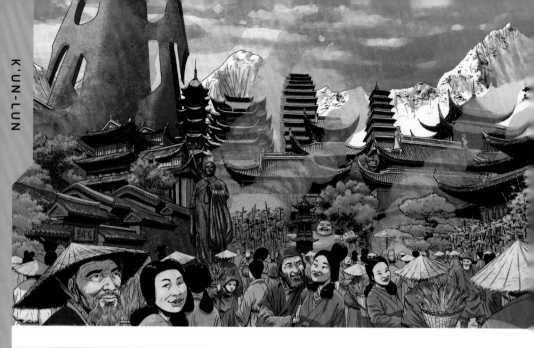

K'UN-LUN

CITY OF THE IMMORTALS

Once a decade, a mysterious city materializes in one of Earth's most treacherous mountain ranges. For centuries, it was believed that the vanishing village of K'un-Lun was merely a fantasy. However, this extradimensional oasis is quite real and well worth a visit—if you can find it!

 ## HISTORY AND CULTURE

Nearly a million years ago, a spaceship of unknown origin crashed into a small planet just beyond the boundaries of our dimension. Trapped at the crash site, the ship's survivors built a beautiful city using material salvaged from the ship's remains. *If we ever crashed our hunk of junk, we'd be lucky if we could build a hot plate. —Rocket*

The ship's malfunctioning warp engines mixed with the native magic of that dimension, causing the crash site to spontaneously shift between its plane of reality and our own. As a result, the city of K'un-Lun now materializes on Earth approximately every ten years in the Himalayan Mountains near Tibet.

AND I THOUGHT THE WAIT FOR SPACE MOUNTAIN WAS LONG . . . –STAR-LORD

K'un-Lun's home dimension is full of ancient magic and fantastic beasts, including enormous dragons. Its warriors, trained by the immortal Thunderer Lei Kung, are respected as some of the most skilled fighters in this universe or any other. *Shall we put that to the test? —Gamora*

ETIQUETTE

Having been secluded from the outside world for so long, K'un-Lun's populace is not very accepting of outsiders. That has begun to change in recent years, thanks to more frequent visits from Earth's heroes.

One visit from us and they'll go right back to their old ways.

The people of K'un-Lun are highly disciplined, trained in both mystic arts and martial arts. To avoid exile, it is best to honor their ancient traditions and to show the locals the utmost respect.

SIGHTS AND ACTIVITIES

Tournament of the Heavenly Cities: K'un-Lun isn't the only otherworldly city that occasionally appears on Earth. In fact, it is just one of the so-called Seven Capital Cities of Heaven. All seven of these cities align once every eighty-eight years and combine to form the Heart of Heaven—a giant palace comprising aspects of all seven cultures. Here, legendary champions from each city compete to strengthen their home realm's ties with Earth. The victor of the tournament wins their home city the honor of appearing on Earth every ten years, while the losing cities must wait fifty years before their next return. Tickets are sold out generations in advance, so expect to pay scalpers top dollar for seats.

88 YEARS? BUT I WANT TO FIGHT IN AN EPIC CROSS-DIMENSIONAL DEATH MATCH NOW! –DRAX

? Did You Know?

- If you just missed K'un-Lun's appearance in this dimension, don't worry. You won't have to wait a decade to visit this mystical realm. There are a number of ways to cross the Bridge of Destiny before the city's next physical manifestation in this dimension, from high-tech teleportation devices to mystical spells.

- The people of K'un-Lun have built strong relationships with the dragons that inhabit their home dimension. In fact, one of the dragons—Shou-Lao the Undying—has long been the source of power for K'un-Lun's greatest protector, the Iron Fist.

- K'un-Lun's oldest structure, the Central Hall of Ancestors, is actually the tail end of the ancient spaceship that originally crashed on this site. *Anyone wanna see what I can do with my tail end?*

I AM GROOT.

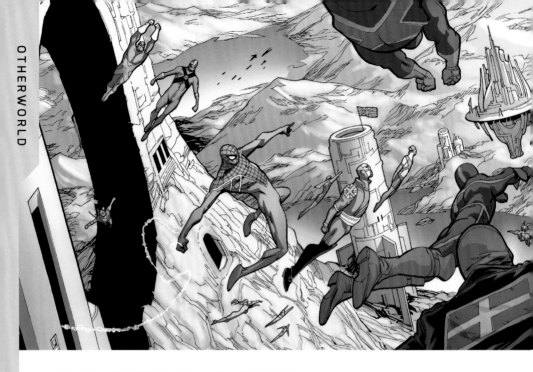

OTHERWORLD

THE OMNIVERSAL HUB OF ALL CROSSTIME

Otherworld is one of the few dimensions completely unique in all of time and space. While almost every alternate universe has an Earth, for instance, allowing for countless variations across all space and time, there is only one singular Otherworld shared by all realities. Here, the greatest heroes in the Omniverse gather to protect all of creation. *we do? —Rocket*

 ## HISTORY AND CULTURE

Otherworld is a small disc-shaped asteroid floating outside reality. The land itself is composed of two main islands, Tir na nÓg and Avalon. The islands take their shape from a strong magical link to Earth's British Isles.

This dimension is the home of several ancient races of mystical beings, including elves, leprechauns, ogres, giants, trolls, and faeries. The landscape of Otherworld is rich with magic older than time and features portals to other realities as well as entrances into dark netherworlds.

Otherworld may be most widely recognized as the base of operations for the multidimensional consortium of protectors known as the Captain Britain Corps. From here, they continue their mission to maintain order throughout the Omniverse.

So, basically, us . . . but with funny accents.
GROOT, I AM!

 ## ETIQUETTE

The British tend to be a polite, well-mannered people, no matter which reality they hail from. However, the other magical races who live in Otherworld can often be quite hostile to outsiders.

WE OUTSIDERS CAN BE QUITE HOSTILE TOO. —DRAX

 ## WHAT TO WEAR

Anything proudly displaying the flag of Britain—the Union Jack—is appropriate.

GOOD THING I PICKED UP THOSE BOXER SHORTS
ON MY LAST VISIT HOME. —STAR-LORD

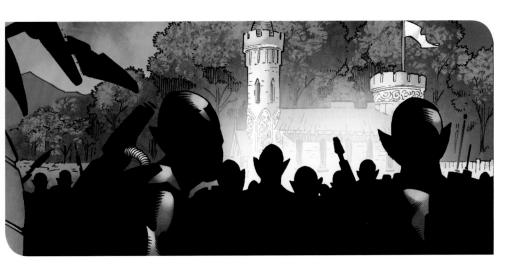

 ## SIGHTS AND ACTIVITIES

Starlight Citadel: This majestic floating tower serves as the home for the Omniversal Guardian, as well as the base of operations for the Captain Britain Corps. It is here that the corpsmen from hundreds of realities assemble to plan their defense against the greatest threats to the Omniverse.

The Green Chapel: This ancient chapel houses some of Otherworld's most powerful magical artifacts, including the Sword of Might and the Amulet of Right—both essential items in the induction of new members to the Captain Britain Corps. The mysterious entity known as the Green Knight has spent centuries guarding the Chapel and its secrets with its life.

IT IS NOT EASY BEING GREEN . . .

But I would not have it any other way. —Gamora

143

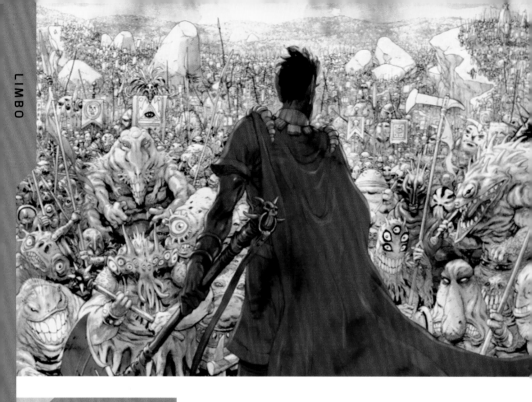

LIMBO

OF DEMONS AND MUTANTS

Limbo is an otherworldly realm forged of dark magic that serves as home to a variety of demons. Recently, Limbo went from a place of damnation to one of salvation when Earth's mutant population moved their sanctuary here.

It is a shame that the X-Men have been forced to live in such a wretched place. —Gamora

I know, right? Limbo! How low can you go? —Rocket

🏛 HISTORY AND CULTURE

Also known as Otherplace, this small pocket dimension is full of fire and brimstone. Though not technically part of the afterlife, it greatly resembles the images of hell described by many religions, with rocky cliffs, lakes of flame, and a sky devoid of stars.

Limbo's primary residents are hordes of demonic creatures versed in the magical arts. These demons are seemingly subservient to whomever currently holds the Soulsword—the ancient arcane weapon bequeathed to the ruler of Limbo; however, they are also notoriously quick to betray their master for personal gain if the right opportunity arises.

One who trusts a demon gets exactly what they deserve.

The dimension draws its power from a heart-shaped deposit of the ultrarare metal promethium. It is said that should the so-called Heart of Limbo be removed, the dimension will cease to exist. *Stealing precious metals AND eliminating nasty demons? Sounds like a win-win!*

 ## ETIQUETTE

When dealing with demons, there is no such thing as etiquette.
GOOD. IT IS NO ONE'S BUSINESS WHICH FORK DRAX USES FOR SALAD! —DRAX

 ## GETTING AROUND

Travel to and from Limbo is most commonly achieved via mystical teleportation via a magical phenomenon known as "stepping discs"—small portals that, when mastered, can grant those who travel through them access to various points in space and time. *I THINK I WOULD PROBABLY TRAVEL TO A TIME WHEN I WAS, YOU KNOW, NOT IN LIMBO. —STAR-LORD*

 ## SIGHTS AND ACTIVITIES

X-Haven: The Jean Grey School for Higher Learning was previously located on Earth's North American continent in Salem Center, Westchester County, New York. There, the mutant heroes known as the X-Men trained to protect a world that hated and feared them. But when the mutant population was threatened with extinction by the Inhuman Terrigen Mists, their only hope for survival was to leave Earth altogether. The school and its inhabitants were relocated to Limbo by the powerful mutant sorceress Magik. Surrounded by a spell of protection against the demons that dwell in Limbo, X-Haven has become the one place in all of reality where Earth's mutants can truly live without fear. Free lodging is available to all mutants and their families. *KITTY ALWAYS TOLD ME THAT BEING A MUTANT COULD BE HELL . . . BUT I DIDN'T REALIZE SHE MEANT IT QUITE SO LITERALLY!*

Did You Know?

• Any outsider who dwells in Limbo will begin to develop demonic attributes— such as horns and a tail—over time. The longer one stays in this realm, the more prominent and permanent the transformation. It has yet to be seen whether the spell of protection encompassing X-Haven will protect the area's residents from this transformation. *There's not one bad thing about having a tail.*

I AM GROOT.

Okay. Pants shopping. Forgot about that.

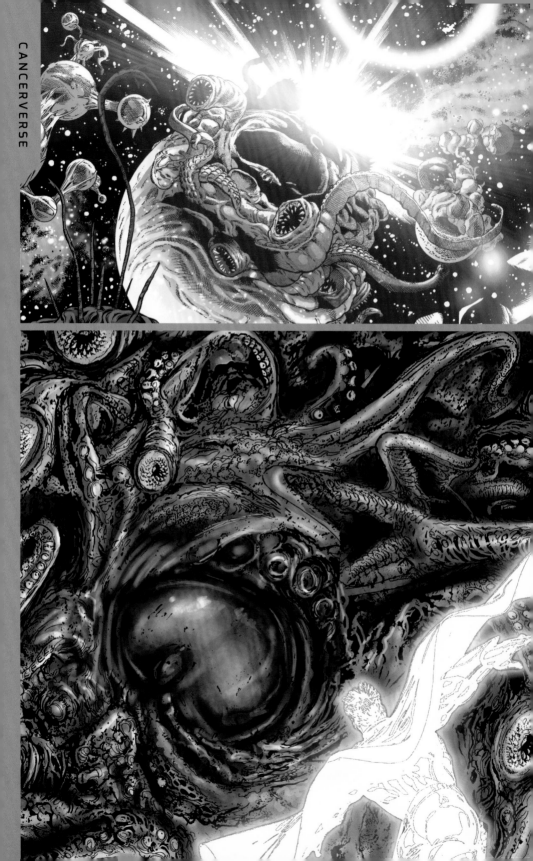

CANCERVERSE

EVERYTHING LIVES

Imagine a universe where death has been defeated and everything lives eternally. Sounds like a paradise—until you realize that every organism in existence would continue to grow unchecked, eventually devouring itself and all of reality. You've just imagined the Cancerverse, a nightmare dimension that is, unfortunately, all too real.

Who puts this flark-hole of a dimension in a frutakin' travel guide? —Rocket

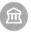 ## HISTORY AND CULTURE

In the Cancerverse, death is no more, thanks to the machinations of the reality's Elder Gods, the Many-Angled Ones.

WHOA. LET'S GET THIS STRAIGHT. YOU CAN DIE THERE? OVER AND OVER? AND IT HURTS LIKE HELL? –STAR-LORD

BUT YOU KEEP COMING BACK. USUALLY NAKED.–DRAX

In essence, the Cancerverse has become one gigantic organic mass. Think of it as the universal equivalent of an overgrown garden, bursting at the seams with life and eager to spread beyond its borders.

I AM GROOT!

Agreed. Such a comparison is insulting to gardens everywhere. —Gamora

Now that their universe has become a seething deathless corpse with no room left to grow and expand, the Many-Angled Ones have begun looking beyond their borders for other universes to envelop.

Though most intelligent independent living organisms in the Cancerverse have become one with its greater living mass, the Many-Angled Ones have chosen a group of champions to remove any threats to the dimension's unfettered growth. These Revengers—corrupt analogues of Earth's Avengers—enforce their masters' quest to consume other worlds.

A FOE THAT NEVER DIES IS SIMPLY ONE THAT YOU MAY HIT FOREVER.

At the climax of a war between the Kree and the Shi'ar, a bomb was detonated that created a massive fissure in space/time. This rift, known as the Fault, allowed the Cancerverse to bleed into our universe. The rift has since been sealed, but not without great sacrifice from some of our universe's greatest heroes. *Rest in peace, Richard Rider.*

We miss ya, bucket head. —Rocket

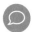 ## ETIQUETTE

Obey the Many-Angled Ones, and you will be granted great gifts. Defy them, and they may actually permit you to die. Painfully.

THE GREATER PUNISHMENT IS TO LET YOU LIVE. PAINFULLY. –STAR-LORD

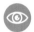 ## SIGHTS AND ACTIVITIES

The Trapezohedron: Though the ruins of some cities remain in the Cancerverse, nearly all of their structures have become overrun by the universe's wild organic growth. The base of the Revengers—the Trapezohedron—is one of the few places completely untouched by the sprawl. The massive building contains all of the team's facilities, including laboratories and containment cells.

Rocket's Travel Tip #127: Never enter a building with a name that starts with the word "trap."

 ## LODGING

The only native beings opposing the Cancerverse's expansion are artificial ones. This collective of android freedom fighters, known as the Machine Resistance, make their home base on Saturn's moon Titan. This is the perfect place to rest and relax before heading back into a dimension that is trying to eat you alive.

 ## Did You Know?

- The Cancerverse can spawn a wide variety of grotesque multitentacled creatures, which it uses to defend itself from invaders and to attack other universes.

- Some extremists have tried to summon the Many-Angled Ones into their own universes by building a Horrorscope, a cross-dimensional homing device combining advanced technology with occult magic.

- For the Cancerverse to properly invade another living universe, a Necropsy must be performed. This ritual locates and eliminates the living entity most closely tied to the concept of death. Once the avatar of death is removed, the Cancerverse is free to spread into that universe unchecked.

Perhaps the only good reason to keep Thanos alive. –Gamora

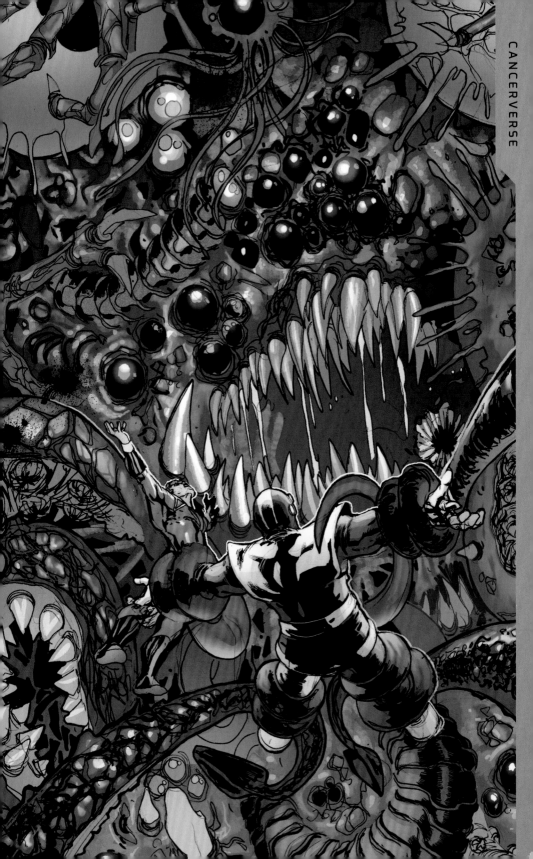

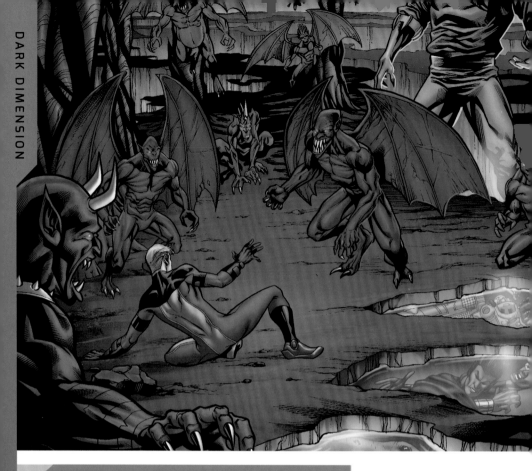

DARK DIMENSION

DOMAIN OF THE DARK ARTS

The only thing more twisted than the Dark Dimension itself (which is composed of hundreds of mystical realms combined into one) is the macabre menagerie of horrific creatures dwelling within its shadows.

 ## HISTORY AND CULTURE

The Dark Dimension is a surreal collection of magical realities, intertwined into one nightmarish landscape. The dimension is covered in warps that lead into its even more bizarre subuniverses.

Despite the many sinister beings that call it home, the Dark Dimension was actually at peace for thousands of years under the rule of King Olnar. Upon the arrival of the banished Faltine sorcerers Dormammu and Umar, though, the Dark Dimension was thrust back into chaos.

WHEN DRAX THRUSTS, IT IS ALWAYS INTO CHAOS! –DRAX

I'M GOING TO PRETEND YOU DIDN'T SAY THAT . . . –STAR-LORD

Dormammu shattered the mystic barrier between the Dark Dimension and a neighboring realm inhabited by the hulking creatures known as the Mindless Ones. These rampaging engines of destruction overran the Dark Dimension, slaying its king and clearing the path for Dormammu to seize control. Under Dormammu's rule, the endless hordes of Mindless Ones have become the Dark Dimension's primary residents.

I can barely deal with the four mindless ones on this ship. —Rocket

The arcane energies of the Dark Dimension directly fuel the dread Dormammu's mystical powers, making him one of the most formidable sorcerers practicing on any plane. On countless occasions, he has attempted to break down the barriers between the Dark Dimension and this universe to absorb even more power into his repugnant realm.

MAYBE OUR DIMENSION WOULD BRIGHTEN THE PLACE UP A BIT.

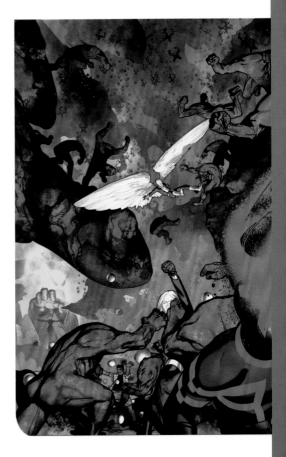

 ## GETTING AROUND

Visiting the Dark Dimension in your physical form is not recommended, considering the countless perils of its landscape. Instead, this dimension is best visited only by those able to mystically project their astral forms.

I AM GROOT?

Last I checked, no. No we can't.

 ## WHAT TO WEAR

If you must come to the Dark Dimension in person, it is essential to be cloaked in a powerful spell of protection. If you happen to have a mystic artifact on your person, such as an Eye of Agamotto or a Crimson Gem of Cyttorak, you will be much more likely to survive your visit with your soul intact.

TOO BAD I LEFT MY WAND OF WATOOMB IN MY OTHER PANTS.

Clearly. —Gamora

DARKFORCE DIMENSION

INTO THE VOID

If every star were snuffed from the sky, our universe would still not be as black as the Darkforce Dimension—a plane of reality completely devoid of light.

JUST WHEN YOU THOUGHT IT COULDN'T GET MORE DEPRESSING THAN THE CANCERVERSE . . . –STAR-LORD

 ## HISTORY AND CULTURE

The Darkforce Dimension is the opposite of most other realities, which are predicated on light. Instead, this dimension is completely composed of a viscous black matter known as Darkforce Energy. With no real shape or form, the Darkforce Energy flows freely throughout the dimension. Because of this, the Darkforce Dimension seems to be nothing but endless blackness, with no discernible concept of space or time.

WHO ELSE THINKS THIS SOUNDS RATHER PLEASANT? –DRAX
EVERY GUY AT MY HIGH SCHOOL WHO WORE EYELINER AND LISTENED TO THE CURE.

On the rare occasion where a breach between our reality and the Darkforce Dimension has occurred, the Darkforce Energy has flowed into our world in an attempt to find a natural balance between light and dark.

Although the Darkforce Energy is not sentient, it has been tapped into by a number of intelligent beings in our reality. These Darkforce-sensitive individuals have been known to use this energy to fly, generate fields of darkness, create physical objects, and, most commonly, to teleport.

There have been claims that Darkforce Energy has a corruptive influence on those who wield it, especially those who harbor high levels of anger and doubt. These allegations, however, have not yet been substantiated.

All those terrible things I've done to you guys over the years? Totally the Darkforce. —Rocket

GETTING AROUND

Getting into the Darkforce Dimension requires the skills of a mystic or teleporter attuned to Darkforce Energy. Be sure not to wander too far from such a guide if you hope to get back out. It is far too easy to get lost in the darkness forever.

Being raised by Thanos has shown me that any darkness can be overcome.
—Gamora

WHAT TO WEAR

When traveling through the Darkforce Dimension, wear reflective clothing and carry a powerful flashlight (like the Spartax Star-Torch X37B). Spare batteries are recommended, as the Darkforce Energy tends to drain light sources of their power at an alarming rate.

SIGHTS AND ACTIVITIES

If there are any noteworthy landmarks in the Darkforce Dimension, they are completely shrouded in the thick blackness of the plane and have not yet been discovered.

DINING AND NIGHTLIFE

None known. *SOUNDS LIKE ALL LIFE IN THE DARKFORCE DIMENSION IS TECHNICALLY NIGHTLIFE. AM I RIGHT?*
BOOOOOOO!

LODGING

Although there are no hotels here, the Darkforce Energy has been known to send visitors into a deep coma-like sleep. This dimension could actually be an insomniac's best friend.

I was just going to say the same thing about this book.

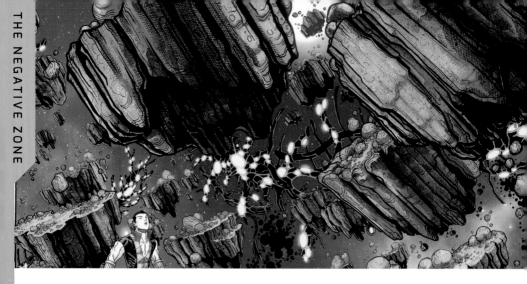

THE NEGATIVE ZONE

A POSITIVELY UNIQUE DESTINATION

Just beyond the Crossroads of Infinity lies the Negative Zone, a bizarre dimension composed completely of antimatter.

Then I guess it doesn't matter. —Rocket

I AM GROOT.

Thank you. I'll be here all week. Tip your wait staff.

 ## HISTORY AND CULTURE

Upon first glance, the vast void of the Negative Zone may seem relatively empty. Yet somewhere beyond the floating chunks of barren rock and vortexes of explosive energy live hundreds of unique alien races and creatures not found in our own dimension. Throughout their history, these beings have attempted to band together almost as often as they have tried to destroy each other.

Thanks to advancements in interdimensional travel, access between our dimension and the Negative Zone has become readily available via a wide variety of portals and jumpgates. Until recently, most of that technology existed only in our universe, keeping some of the Negative Zone's more volatile races safely within their own dimension.

If only they had stayed there. —Gamora

When one of these hostile creatures, Annihilus, realized that our universe was expanding into the space occupied by the Negative Zone, he breached the barrier between universes and sent out an Annihilation Wave—an enormous swarm of ravenous alien insects that devoured everything in their path. Though both dimensions suffered untold damage, the threat has been contained.

YOU'RE WELCOME. –STAR-LORD

WHAT TO WEAR

Though the Negative Zone may in some ways resemble our own depths of space, the entire dimension actually contains atmospheric conditions capable of sustaining most life. Therefore, a pressurized space suit and life-support system are not required when exploring.

The Negative Zone tends to be a bit chilly, though—averaging just below 40 degrees Fahrenheit—so be sure to dress appropriately.

Come for the bugs, stay for the near-freezing nothingness!

SIGHTS AND ACTIVITIES

Prison 42: Earth's heroes once built a supermaximum-security prison in the Negative Zone to safely house their deadliest criminals. Since being abandoned, the hulking structure has been the site of several major conflicts. Its reinforced corridors make it the perfect place to stop and take a breather while waiting for a ravenous alien horde to pass you by. *Still one of the best prisons I've ever fought my way out of.*

TIPS FOR A FUN TRIP

DO: Take your time. Time flows more quickly in some regions of the Negative Zone than it does in our dimension. That means you can pack an entire week's vacation into just a few short hours!

DON'T: Go near the Distortion Area! This gravitational anomaly attracts all mass, causing positively charged matter and negatively charged matter to collide, with explosive results! *OR HURL YOUR ENEMIES INTO IT AND ENJOY THE SHOW. —DRAX*

? Did You Know?

- The antimatter of which the Negative Zone is composed has long been tapped into as a source of power for the beings of our universe, from the Kree to the Nuwali.

- Reed Richards of the Fantastic Four perfected a portal to the Negative Zone. Although the original was housed in the Baxter Building on Earth, his technology was re-created by dozens of other scientists across the universe seeking access to this dimension.

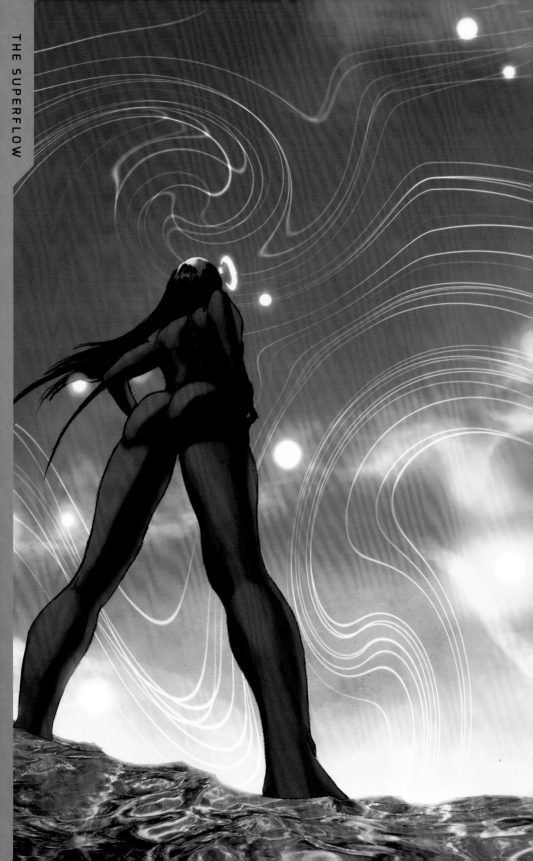

THE SUPERFLOW

THE GREAT BEYOND

While most of the dimensions we've explored simply exist beyond our own reality, there are a few realms that exist outside the boundaries of every reality. These regions serve as the connective tissue of the Omniverse, linking every possible plane of existence together.

It's rare for one to travel to the Superflow in person, but we've all visited there before in our sleep. The Superflow is the extradimensional realm where all dreams and ideas originate—though its red skies, volatile weather patterns, and rough waters are often akin to the stuff of nightmares.

IF THIS IS WHERE MY DREAMS ORIGINATE, YOU GUYS ARE DEFINITELY NOT ALLOWED IN. —STAR-LORD

Every individual universe is said to have its own Superflow, connected to all others via a Central Web—the nexus of all Superflows. The Superflow has its own unique set of physical laws, allowing for visitors to alter their appearance and to travel exponentially faster. For those able to access this plane, the Superflow can be treated as the ultimate shortcut between any two points in space.

I AM GROOT?

Hey! It would've been a shortcut if you hadn't taken that left turn at Al'Bik'Irki . . . —Rocket

Each individual Superflow previously contained a high-tech communication station constructed by an ancient race called the Builders. These stations were created to initiate a White Event—a phenomenon designed to protect worlds deemed ready to rise to a new level of universal importance. A major cataclysm caused the destruction of these stations, however, leaving them uninhabited. Now, these ancient god-machines float abandoned and forgotten.

The only thing I love more than looting junkyards is looting outer space dream-world junkyards!

THE NEUTRAL ZONE

WHERE EVERYTHING ENDS

Just outside the Superflow lies the Neutral Zone, a strange dimension beyond the farthest edge of all things. Also known as Exo-Space, here both negative and positive matter are able to coexist without the explosive reactions witnessed when they collide in other dimensions.

BUT THE EXPLOSION WAS THE BEST PART! —DRAX

This bizarre dimension serves as home to ancient gods and predatory beasts long forgotten by the modern world. These scavengers of the outer Omniverse include shoggoths, Exo-Parasites, viral parallels, and more—all of them eager to cross into reality and devour it.

I shall whet their appetites with my sword. —Gamora

The Neutral Zone is said to be the furthest one can go before reaching the absolute end of all known realities.

AND THIS IS APPARENTLY AS FAR AS WE CAN GO FOR OUR $19.99. —STAR-LORD

It's been fun, kids! If you're ever floating aimlessly through space, call us. Go ahead, give 'em our number, Groot. They earned it. —Rocket

I-A-M-G-R-O-O-T.

Heh. That never gets old.

INSIGHT EDITIONS

PO Box 3088
San Rafael, CA 94912
www.insighteditions.com

 Find us on Facebook: www.facebook.com/InsightEditions
Follow us on Twitter: @insighteditions

© 2017 MARVEL

Library of Congress Cataloging-in-Publication Data available.

ISBN: 978-1-60887-854-3

Publisher: Raoul Goff
Acquisitions Manager: Robbie Schmidt
Art Director: Chrissy Kwasnik
Designer: Ashley Quackenbush
Executive Editor: Vanessa Lopez
Editorial and Production Manager: Alan Kaplan
Senior Editor: Chris Prince
Production Editor: Elaine Ou
Production Managers: Carol Rough and Lina sp Temena
Production Assistants: Sam Taylor and Jacob Frink
Editorial Assistant: Katie DeSandro

Insight Editions would like to thank David Gabriel, Jeff Youngquist,
Joseph Hochstein, Sarah Brunstad, Jeffrey Reingold, and Curt Baker.

ROOTS of PEACE REPLANTED PAPER

Insight Editions, in association with Roots of Peace, will plant two trees for each tree
used in the manufacturing of this book. Roots of Peace is an internationally renowned
humanitarian organization dedicated to eradicating land mines worldwide and converting
war-torn lands into productive farms and wildlife habitats. Roots of Peace will plant two
million fruit and nut trees in Afghanistan and provide farmers there
with the skills and support necessary for sustainable land use.

Manufactured in China by Insight Editions

10 9 8 7 6 5 4 3 2 1